Symbols of Islam

Tanja Al Hariri-Wendel

Symbols
of
Islam

Sterling Publishing Co., Inc.
New York

**Library of Congress Cataloging-in-Publication
Data Available**

10 9 8 7 6 5 4 3 2 1

Published in 2002 by Sterling Publishing Co., Inc.
387 Park Avenue South, New York, NY 10016
Originally published in Germany under the title
Symbole des Islam by Schirner Verlag
Landwehrstr. 7a, Darmstadt, D-64293
© 1999 by Schirnerl Verlag
English Translation © 2002 by Sterling Publishing
Distributed in Canada by Sterling Publishing
^c/o Canadian Manda Group, One Atlantic Avenue,
Suite 105, Toronto, Ontario, M6K 3E7, Canada
Distributed in Great Britain and Europe by
Chrysalis Books
64 Brewery Road, London, N7 9NT, England
Distributed in Australia by
Capricorn Link (Australia) Pty Ltd.
P.O. Box 704, Windsor, NSW 2756, Australia

Sterling ISBN 1-4027-0034-2

Contents

Acknowledgments

The publication of this book is a result of the open-mindedness of Schirner Publications. The editors suggested writing a book about Islam and its symbolism, despite the social problems inherent in the subject. I would like to express my gratitude for the chance to move beyond the prejudices and misunderstandings caused by language barriers.

I offer special thanks to my family, who supported me in this project. I also would like to express gratitude to my husband, who helped me search for literature in Damascus and who assisted with the translations of the original Arabic literature. In addition, I thank my son, who often sat more or less patiently with his toy next to my desk, occasionally voicing his displeasure. He freely criticized me by scribbling on my manuscript. At times, he made a page simply disappear or even ripped it apart. He probably did this to prepare me mentally for what could be in store for the book after its publication.

I also would like to thank the Islamic theologian, Ms. Halima Krausen, for her honest interest, her helpful hints, and her critical annotations regarding the second and third parts of the book. Further thanks go to Ms. Nashua Haffar and the Al Assad Library in Damascus for their friendly and professional assistance in helping me find my way around within the literature. In addition, I thank Dr. Hind Rifai, Ms. Renate Schüler, and Mr. Abdul Haqq Pankonin for providing me with their books.

Explanations

Definitions

Unless otherwise indicated, when we speak of Muslims in this book, we mean the community of all believers in Islam—women and men.

"Tradition" or "traditional" refers to behavior passed on from one generation to the next but which is not specifically found in Islam.

Translations

Arabic terms are explained and translated in context within the text. As an additional aid, we've included a glossary following the third part of this book.

Transcription of Arabic vowels:

The vocals **A, a, I, i, U**, u are pronounced long.

The letter **h** is pronounced like a hissing sound, which takes place between the pressed palate and throat

The underlined **th** is pronounced like the English "th," for example, as the word "think."

The **ch** is a throat sound, which is always pronounced like the Scottish "ch," for example, in the word 'Loch (Ness).'

The letter **Š**, or **š** corresponds to the English "sh"-sound.

The letter Z, or z is pronounced like the voiced "sc" in the word "scissors."

The **dsh** is voiced like the "g" in "genie."

Allahu 'alam

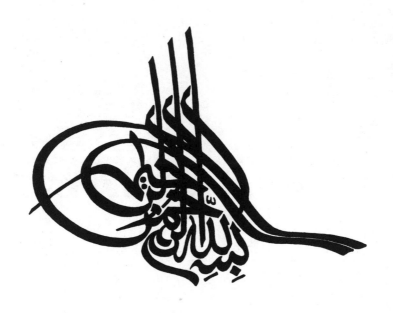

Calligraphy: "Bismi'llahi'r-Rahmani 'r-Rahim."

Preface

More than one billion people, about one-fifth of the world's population, are Muslims. More than 20 million Muslims live in Western Europe and the United States, and their numbers are increasing worldwide. While Christianity is the world's largest religion, Islam is the second largest.

Despite the fact that we live in the information age, our media, which calls itself enlightened, often lacks information about Islam. People tend to view Islam with prejudice and mistrust or as if it were a fairy tale from *One Thousand and One Arabian Nights*. Unfortunately, the media sometimes contributes more confusion than enlightenment. Some journalists use surprising quotations supposedly taken from the Koran, the Holy Scripture of the Muslims. Some versions of the Koran, translated by non-Muslims, are not accurate or precise. They can have an intimidating effect rather than an inviting one on even the most open-minded readers. This is especially true for female readers. The antiquated version by Max Henning, for example, translates the fourth Surah of the Koran in a way that is not at all flattering towards women. At several points, the impression is that Paradise is only for men. Unfortunately, translations leave conclusions to the preconceived ideas of the translators. Thus, an objective insight into Islam is difficult to find.

Meanwhile, the gaps and chasms between religions are not as deep as they might appear to some of us. For Muslims, for example, Jesus is not the Son of God, but rather one of the prophets, the son of the Virgin Mary, and the Messiah. According to Islamic revelation and transmission, Jesus will reappear when the world comes to an end. Contrary to Christians, however, Muslims, reject the polytheistic doctrine of the Trinity (the unity of the Father, the Son, and the Holy Spirit). In fact, the Trinity doctrine was first pushed through under Constantine the Great

at the council of Nicæa in the year 325 A.D. Under Constantine, Christianity was the equal of traditional Roman paganism. However, the new acceptance of the Trinity doctrine created an immediate conflict with the old Christian ideas that had far-reaching consequences. At the council of Nicæa, the previous doctrine, in which Jesus was not of equal nature with God, was condemned. The change was due to Constantine's influence. This is the same Constantine who built heathen temples, had himself presented as Jupiter according to the Roman emperor worship, and was honored as a god by the heathens. Nevertheless, although not a Christian himself, Constantine wanted to be celebrated as the first great Christian ruler. Clearly, his dedication towards Christianity was mainly in harmony with his political goals; the persecution of Christians had backfired. Thus, the doctrine of the Trinity sounds more like a political compromise between the heathens and the Christians. The heathens prayed to several gods and knew that the Romans had a weakness for divine triads such as Jupiter, Mars, and Quirinus; and the Christians could not be driven out of the Roman Empire. Only on his deathbed did Constantine receive baptism. Why should the Trinity, which is the quintessence of Christian belief and dogma, be derived from such a questionable person as Constantine the Great? No original Aramaic texts from the time of Jesus have survived. Everything upon which we base our knowledge is from later sources and translations; in contemporary biblical research, we assume that the biblical texts were changed over time.

Another difference between Christians and Muslims is that Muslims believe Jesus was not crucified and murdered. However, it was made to appear as if that had occurred. Islamic doctrine states that one of Jesus' companions, who happened to look like him, was murdered on the cross. Since Jesus was not murdered, the question of the Resurrection is removed from Islam. In this

context, the Ascension of Christ (Acts 1.9-11), according to which Jesus rose to heaven after his earthly Resurrection, only became part of Christian belief around the fourth century. In addition, some Christian theologians are of the opinion that the historical accuracy of Jesus' Resurrection is very doubtful.

On the other hand, the differences between Muslims and Jews might be attributed to family and inheritance as well as to territorial disputes. These had their origins as far back as Abraham, the tribal father of both the Arabic and the Jewish tribes. The Arabic people descend from Abraham's second wife, Hagar, who gave birth to Ishmael, Abraham's first son. Later on, Abraham's first wife, Sarah, delivered his second son, Isaac (Ishak), from whom the Jewish people descend. Jesus had Jewish roots through his mother, Mary. According to the tradition of the New Testament, Jesus had not been sent to abolish the Mosaic Law (Matthew 5.17). The Prophet Muhammad descends from the Arabic line. This fact is not taken into consideration in the translation of the Bible.

Actually, Muslims have several things in common with Jewish people. Two areas of common practice are the dietary strictures and the circumcision of male descendents. (No pork, no meat from perished life, no blood, etc. Compare Leviticus 11.7-10 and Surah 5.3 in the Koran). The Coptic and Syrian-Orthodox Christians also strictly adhere to the dietary prohibitions found in the Old Testament.

The Crusades occurred between the eleventh and thirteenth centuries A.D. They strained the relationships between all three religions (Judaism, Christianity, and Islam) even further. History has a convenient tendency to overlook the fact that the Crusaders brought back important Hellenistic-Arabian achievements in the fields of mathematics, astronomy, optics, alchemy, natural science, geography, medicine, philosophy, theology, and mysticism to the Western world.

Both medieval and modern Western artisans have benefited from Islamic culture.

The Roman Catholic Church has endeavored to establish a dialogue with Muslims. This is a very welcome overture because, unfortunately, few Western people know of the common religious roots of Muslims, Christians, and Jews. In the Koran, Jews and Christians are designated as "People of Scripture" (Ahl al-Kitab). As Dhimmi (protected civilians), they enjoy the protection and tolerance of the Islamic state and autonomy regarding legal questions. The Koran accepts the Torah of Moses and the Gospels of Jesus as revelations. For example, the Psalms of David are also mentioned in the Koran as supplications (Du'a'). According to Islamic theology, all prophets essentially preached nothing more than Islam: the belief in one sole, almighty God and the devotion of the people to God. However, these earlier revelations (Torah and Gospels) were later changed by Man.

Twenty-one out of the twenty-eight prophets who are mentioned in the Koran also appear in the Bible. However, some of the Biblical prophets deliver a rather flawed picture of life and lifestyle, and these are contrary to the revelation of the Koran.

Some of the most famous prophets named are Adam (Adam), Noah (Nuh), Abraham (Ibrahim), Lot (Lut), Jacob (Ya'qub), Joseph (Yusuf), Moses (Musa), David (Da'ud), Solomon (Suleiman), Jonah (Yunus), Enoch (Idris), Job (Ayyub), John the Baptist (Yahya), and Jesus (Isa). In Islam, Muhammad is considered the seal of the prophets, and the Koran becomes final revelation (Surah 33.40).

Despite their common roots, Jews, Christians, and Muslims don't seem to have much success in living together peacefully. Throughout history, members of all three faiths have carried out countless "holy" wars and assassinations in the name of God. Yet each religion teaches that they should not kill each other but rather "compete in good deeds."

The general population's knowledge of Islam is limited but increasing. However, the question of who is supplying the information becomes very important. Many Muslims feel uneasy about the source of the information the average citizen has about Islam. This is understandable. However, the fact that all Muslims do not agree, does not justify using Christians to explain Islam, particularly considering the language barriers. In addition, this uneasiness is increased by the fact that the quality of many of the translations of the Koran is poor. A more practical solution would be to leave the translating to English-speaking Muslims.

This book will provide the reader with a differentiated insight into the history (and prehistory) of Islam as well as into the details and background of Islamic practices. The terms "symbol" and "symbolic" are not secret signs in the sense of a pictorial language and its interpretation. Listing symbols alphabetically (including symbolic acts and their significance in Islam) is not possible and is usually undesirable because it only leads to fractured and partial knowledge. Thus, individual customs and their manifestation through specific acts are explained in context with the subject to which they belong. This produces a clear picture of Muslim practice. The version of the Koran used in this book was translated by Muslims.

In the third part of the book, we discuss contradictions within Islamic countries and oriental superstitions. We use examples that are often mistakenly linked to Islam. This part of the book contains some very interesting details, even for some Muslims who might not be aware of the incompatibility of certain practices of "folk piousness" with Islamic doctrine.

Because of the restrictions imposed by time and space, each part of the book is necessarily limited in scope. We cannot claim that any one part is complete. However, we hope that it may impart a basic knowledge that invites the reader to expand his or her knowledge.

The focus is on Islamic symbolism. This is a lively subject. Most of us confront Islam daily, through the media or in personal contacts with Muslim colleagues or neighbors. Many of the topics we will discuss raise questions for non-Muslims. We will also tackle current topics that are somewhat problematic and troublesome.

The humorous, spicy irony that occasionally accompanies the text is deliberate because we want the reader to think carefully about the material. Hopefully, we will be successful in explaining concepts so that we can clear up some misunderstandings and prejudices.

A visible influence of Islamic artisanship in Europe: a Moorish design found in the Alhambra in Granada, Spain (fifteenth century A.D.).

Introduction

The first part of this book deals with the developments of Arabic paganism in the pre-Islamic period and presents a picture of society and religious life shortly before the revelation of the Koran.

The information and descriptions about the individual idols are primarily based on the translation of the idol book of Ibn al-Kalbi, the *Kitab al-Asnam*, as well as its evaluation and interpretation within the context of religion and history. Ibn al-Kalbi was the most renowned scholar of tradition, genealogy, and the history of ancient Arabia. He was the first scholar who dedicated himself to Arabian paganism and one of the outstanding figures of the Kufig School of philology, an institution with a tendency towards strict interpretations.

The Hegira (Hijrah) is the name given to the flight of the Prophet and his companions from Mecca to Medina in 622 A.D. The Islamic calendar begins with the Hijrah. In the second and third centuries of the Hijrah, under the ruling Abbasids, the Iraqi cities of Kufa and Basra were two famous scientific centers.

The *Book of Idols* is a collection of customs and traditions stemming from statements about the idol worship of the pre-Islamic period and is the only ancient Arabian monograph about Arabian paganism. In order to simplify this book, the list of people who passed on the tradition (those who received statements about the pre-Islamic period from other people) was omitted. In addition, we have only discussed those pagan idols and customs that were also mentioned by name in the Koran or in the Hadiths (the sayings of the Prophet Muhammad) and who

were closely connected to the Ka'bah in Mecca. In this way, we have created an overall appearance about prehistoric Islam, Islam itself, and oriental superstition.

The second part of the book deals with the basic ideas of Islamic belief, its consequences, and the relationship between Islam and the everyday life of Muslims. In addition, this part of the book examines the significance of individual acts and developments.

The third part of the book discusses the superstitious customs that still exist today. This section will also allow the reader to recognize many of the superstitious ideas from the pre-Islamic period.

PART ONE

Arabia

in the Pre-Islamic Period

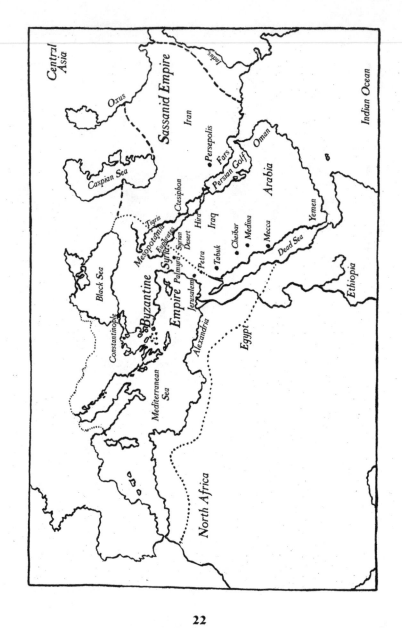

22

The Political and Cultural Conditions of Arabia at the Beginning of the Seventh Century A.D.

In the year 600 A.D., the Near East was divided between two empires: the predominately Christian Greco-Roman Byzantium and the Zoroastrian Sassanian Persia. Although these areas had reached a high level of cultural sophistication, the political and cultural situation of the Arabian Peninsula (Arabia) resembled a fairy-tale slumber. In most history books, the only mention of pre-Islamic Arabian culture is the art of poetry.

With a few exceptions in ancient southern Arabia, where some kingdoms existed from approximately 500 B.C. until the sixth century A.D., Arabia did not have any united social or political organization. Cities such as Mecca and Medina, for example, gained their significance more from trade than from their political power.

Despite the lack of a coherent state organization, there were relatively large villages and cities. The inhabitants of these areas viewed themselves as belonging to certain tribes such as the Bedouins and Nomads, and they adopted the same type of simple legal patterns. The most important legal right of the Bedouins was the right of personal freedom, in spite of the many kinds of family bonds and the binding identification of one's tribe.

> Although the tribal chiefs were treated with respect, they had neither the right nor the authority to order people around. The second essential right of the tribe was that of robbing other tribes. The Bedouins'

A southern Arabic Holy Scripture (approximately tenth century B.C.).

struggle for survival took place in battles over meadows and watering areas for cattle. Water was rare and precious because the areas were barren of vegetation.

Though these battles were vital, they were limited. No national or cross-tribal identity developed because the Bedouin only thought in terms of the dimensions in which the family and tribe lived. The only limit for these battles was blood revenge. In rare cases, family members accepted a blood price (Diyah), a type of indemnification and compensation that is still customary today. Almost always, however, they also claimed the blood of the murderer. When the anger was particularly high, the blood revenge extended to family members or other members of the tribe.

Despite the fact that the hostile, barren surroundings did not provide luxurious conditions for any reconciliation between the tribes, hospitality was a still a requirement for the Bedouins.

The religion of the independent Arabs did not reach a very sophisticated level of development. There were a number of tribal and household gods (lares), whose features were linked to certain places and objects. These were statues, stones, and trees upon which names were listed as inscriptions. In this stone and tree cult, rather than honoring the objects themselves, the Arabs honored the characters that lived inside these objects. Other cults practiced by the pagan Arabs included the ancestor cult and the star cult, but neither was anywhere near as popular as the stone cult.

As a case in point, all Arabs in Mecca worshipped the idol they had in their house. When an individual wanted to go on a journey, the last thing he did before he left home was to stroke the idol with his hand. After his return, the first thing he did after entering the house was to stroke the idol again. There were even household gods that had been formed out of dates or date sauce and were eaten in case of hunger.

The names of the most famous idols were honored by the greater public. They were often part of the names of tribal members who thought themselves under the protection of an individual idol.

The Religion of Abraham and the Ka'bah

The religion of Abraham consisted of the belief in one sole, transcendental God; it was plainly monotheistic.

At God's behest, Abraham left his second wife, Hagar, and his little son, Ishmael, in the desert on the caravan road towards Yemen. An angel led Hagar, who was desperately walking back and forth between the hills of as-Safa and al-Marwah looking for water, to the spring of Zamzam. This spring was the origin of Mecca. Gradually, it developed into a city as travelers took up residence and settled there.

When Ishmael had grown into a man, God gave the order to Abraham and Ishmael to set up a place of worship in Mecca—the Ka'bah:

The first House (of worship)
Appointed for men
Was that at Bakka,
Full of blessing
And of guidance
For all kinds of beings.
In it are Signs
Manifest, (for example),
The Station of Abraham . . .

(Surah 3.96–97)

Remember We made the House
A place of assembly for men
And a place of safety;
And take ye the Station
Of Abraham as a place
Of prayer; . . .

(Surah 2.125)

The pilgrimage to the Ka'bah in Mecca is connected with a number of rites. These include, among others, the circumambulation around the Ka'bah; the walk back and forth between the hills of Safa and Marwah in remembrance of Hagar looking for water; the demonstration of loyalty to God on 'Arafat Mountain; the symbolic stoning of Satan in Mina; the slaughtering of a sacrificial animal; and the shortening of the hair towards the end of the procession. These rituals had been practiced during the pre-Islamic period. The religion of Abraham and the ritual of the pilgrimage, called the Hajj, are basically identical with Islam and the Muslim procedure with Hajj. Because these rites refer back to Abraham, the Ka'bah and the Hajj are not pagan in origin; that is to say, they are not the innovations of pagan Arabs before the time of Muhammad.

The Arabs continued the Hajj according to the custom of Abraham; in time, pagan and polytheistic elements replaced the original, monotheistic religion of Abraham, destroying the significance of the individual rituals. Thus, many elements were introduced afterwards that did not belong to the original ritual. Idols were introduced alongside God (Allah). The pagan Arabs considered Allah to be an important God, and the idols were considered to be mediators. Even around the Ka'bah, there were supposed to be three hundred and sixty idols.

The spread of idol worship was aided by the fact that the pagan Arabs never undertook a journey without taking a stone from the holy district of the Ka'bah. Whenever they rested on their journey, they put down the stone they had brought along and paced a circle (ad-Dawar) around it, just as if they were circling around the Ka'bah. They believed this would bring them luck. The pagan Arabs were supposed to have thrown offerings to their divinities into the spring of Zamzam, just as the North Semites were supposed to have done with their holy springs.

'Amr Ibn Lu<u>h</u>aij and Idol Worship in Arabia

According to tradition, 'Amr Ibn Lu<u>h</u>aij changed the religion of Abraham, the belief in one God, and set up idol statues in Mecca. As a young man, he fought the Jurhum, a tribe that once emigrated from Yemen and was descended from Ishmael. This tribe settled in Mecca, ruled it, and was entrusted with the administration of the Ka'bah. Later on, 'Amr Ibn Luhai also fought the descendants of Ishmael. He was victorious over them and expelled them from the city of Mecca. As a result, 'Amr Ibn Luhai took on the role of custodian of the Ka'bah. Soon afterwards, he became seriously ill. He was told to visit a hot spring in al-Balqa', Syria and to bathe in the spring. He followed the advice and recovered from his illness. 'Amr Ibn Lu<u>h</u>aij noticed that the people there worshipped idols. When rain was required or help was needed against enemies, these people prayed to their idols. He asked the natives for some of their idols, and he set them up around the Ka'bah after he returned to Mecca. In addition to introducing new idols, he also encouraged the Arabs to return to their worship of the old idols from the time of Noah.

According to a statement of the Prophet Muhammad, 'Amr Ibn Lu<u>h</u>aij was the first to introduce pagan customs to Bahira, Wasila, Sa'iba, and Hami.

A male grave statue (first century B.C.).

The Idols of Noah's Time

Noah said, "O my Lord!
They have disobeyed me,
But they follow (men)
Whose wealth and children
Give them no increase
But only loss.
And they have devised
A tremendous plot.
And they have said
(To each other),
'Abandon not your gods.
Abandon neither Wadd
Nor Suwa', neither
Yaguth nor Ya'uq,
Nor Nasr'."
They have already
Misled many . . .

(Surah 71.21-24)

Wadd, Suwa', Yaghuth, Ya'uq, and Nasr were the idols of Noah's contemporaries. Their portraits were created in the era of Jared. According to the tradition, Wadd, Suwa', Yaghuth, Ya'uq, and Nasr' were pious people who all died within one month. Their relatives were very sad about this loss, and one of Cain's descendants asked, "Shall I manufacture five idols according to their likenesses? The only thing I cannot do is to breathe new life into them." The people agreed. He carved five idols and set them up for them. Thus, people in the first generation would come to honor their deceased relatives and to circle them as they did the Ka'bah.

The second generation was even more devoted to these idols. People of the third generation said, "Our forefathers only honored these idols because they wanted them to intercede with God." And from this point on, the idols themselves were worshipped. Because of their disbelief and their idol worship, God sent the prophet Idris. He urged the people to return to the belief in one God, yet they called Idris a liar. At this point, God brought Idris to himself.

The people's disbelief increased until God sent the prophet Noah. He was four hundred and eighty years old when he called for people to return to a singular God. But the people called him a liar, too; and they did not follow him. Then, God ordered him to build the ark. When his work was completed, he was six hundred years old. The Flood came and covered the entire earth for forty years. The water of the Flood swept away the five idols from the mountain of Naud. The current pushed them into the area of Judda. When the floodwaters retreated, the idols remained lying at the seashore. The wind swept sand over them until they were completely covered by sand.

In the meantime, 'Amr Ibn Luhaij had won power in Mecca and was now a soothsayer (Kahin) and the guardian of the Ka'bah. He had a comrade named Abu Thumama who belonged to the jinn. This demon told 'Amr Ibn Luhaij to leave Tihama immediately and go to the harbor of Mecca. There, he would find the idols. He was to bring them to Tihama. Then, they should order the Arabs to pray to these idols.

'Amr Ibn Luhaij did as he was told. He recovered the idols from the seashore of Judda and brought them to Tihama. When the time of the Hajj arrived, he urged all Arabs to pray to these five idols.

Wadd

He gave the idol Wadd to 'Awf ibn-'Udhrah from the Kalb tribe. The latter carried the idol to the valley Wadi Al-Qura and set it up in Dumat Al-Jandal. 'Auf Ibn Udra was the first of the Arabs to name his son 'Abd Wadd (servant of Wadd). Soon, other Arabs also created names with Wadd. 'Auf Ibn Udra, for example, named his other son 'Amir or 'Amir al-Ajdar, the guardian of the idol Wadd. His successors were the guardians of the idol until Islam was revealed. In this custodial role of guarding the idol, the priesthood was always linked to one particular idol. After the revelation of Islam, the idol Wadd was destroyed by Khalid Ibn al-Walid, the general of the Prophet Muhammad.

Wadd is described as a very large statue of a man on which two robes, an undervestment, and a shawl were carved. He had a sword strapped around his body and carried a bow on his shoulder. In front of him, he had a lance with a leather quiver with arrows. Wadd is translated as "friendship" or "affection."

Suwa'

'Amr Ibn Lu<u>h</u>aij had handed the idol Suwa' to a man named Al-Hari<u>th</u> of the Hudhayl tribe. The guardianship, and subsequently the priesthood, for this idol belonged to the descendants of Lihjans, a subtribe of the Hudhayl. The statue of the idol Suwa' was situated in the area of al-Ruha in the valley of Naklah. All the tribes that settled there honored him. The meaning of "Suwa'" is not known.

This idol is mentioned by name in the following ancient Arabic transcript:

One can see them crowding around the king, like the Hudhayl crowded around Suwa', to whose side, floored close to him, laid sacrificial animals of worthiest possession of each Shepard.

We assume that Suwa' was a moon god.

Yaghuth

Yaghuth was the idol worshipped by the Madhij. 'Amr Ibn Luḥaij had given the idol to An'am Ibn 'Amr al-Muradi, who thus became the forefather of the family of guardians. The hill on which the idol was placed and the tribe that settled there carried the name Madhij. At one time, it was supposed to have been the gathering court and cult site of the Yemenite tribe.

Yaghuth means "helper." Since other idols were also helpers, this description does not provide us with any deeper clues regarding the proper, specific symbolism of this idol. Yaghuth is mentioned by name in an ancient Arabic transcript:

Yaghuth accompanied us against the Murad. And we fought against them before dawn.

This record provides us with information about pre-Islamic battle customs since each tribe apparently had its own idol. The idols were mascots and were used for protection.

Ya'uq

'Amr Ibn Lu<u>h</u>aij had handed the idol Ya'uq to Malik Ibn Jusham from the Hamdan tribe. The idol was set up between the Yemenite capital, San'a, and the village Shaiwan, close to the city of Mecca where the Hamdan and the neighboring Yemenites worshipped him. The symbolic meaning of this idol is not known.

Nasr

Nasr means "eagle" or "vulture." Himyar, an old Yemenite tribe, chose this idol for themselves. This vulture god was probably originally the totem animal of Himyar. The cult was located in al-Balqa' in the land of Saba.

In addition, the Himyar owned a temple in San'a. They worshipped and brought sacrifices to this temple. According to tradition, voices were heard coming out of the interior of the temple. However, such a phenomenon was not considered unusual, given the business acumen of the temple custodians in the pre-Islamic period. Upon the request of two Jewish rabbis, the temple was later destroyed; and the Yemenite people converted to Judaism under the King of the Himyar, Dhu Nuwas, who ruled from about 521 to 526 A.D. By the time the Prophet Muhammad sent his messengers towards Yemen, the empire of the Himyar had long since been destroyed. Islam barely met any resistance.

According to Daryabadi, the vulture god Nasr symbolized astuteness and insight.

Bahira, Wasila, Sa'iba, and Hami

Aside from the statements that have been passed on by the Prophet Muhammad, the so-called Hadiths, Bahira, Wasila, Sa'iba, and Hami are also mentioned in the Koran:

It was not God
Who instituted (superstitions
Like those of) a slit-ear
She-camel, or a she-camel
Let loose for free pasture,
Or idol sacrifices for
Twin-births in animals,
Or stallion-camels
Freed from work.
It is blasphemers
Who invent a lie
Against God; but most
Of them lack wisdom.

(Surah 5.103)

Literally translated, Bahira means "whose ear has been slit." Pagan Arabs released a she-camel for the gods. No one could ride or milk the camel after she had given birth five times and the fifth offspring was a stallion. As a sign of her release, her ear was slit.

Sa'iba means "set free." This also involves a she-camel. Based on a vow, the camel was set free by pagan Arabs. As was the case with Bahira, this camel could not be used for milk or transportation.

Wasila means "she has linked the male one with the female one." This was a she-camel or sheep mother. The pagan Arabs would free the animal after it had given birth to an equal number of male and female descendants in her seventh delivery.

Hami means "his back protected." In this case, a male camel was not ridden or sheared after siring ten offspring.

Manah, al-Lat, and al-'Uzza

*Have ye seen
Lat, and 'Uzza,
And another,
The third (goddess), Manat?
What! For you
The male sex,
And for Him, the female?
Behold, such would be
Indeed a division
Most unfair!
These are nothing but names
Which ye have devised,
Ye and your fathers,
For which God has sent
Down no authority (whatever).
They follow nothing but
Conjecture and what
Their own souls desire!
Even though there has already
Come to them Guidance
From their Lord!*

(Surah 53.19–23)

*Now ask them their opinion:
Is it that thy Lord
Has (only) daughters, and they
Have sons?
Or that We created
The angels female, and they
Are witnesses (thereto)?
Is it not that they
Say, from their own invention,
"God has begotten children"?*

> *But they are liars!*
> *Did He (then) choose*
> *Daughters rather than sons?*
> *What is the matter*
> *With you? How judge ye?*
> *Will ye not then*
> *Receive admonition?*

(Surah 37.149-155)

Pagan Arabs regarded the idols Manah, al-Lat, and al-'Uzza as daughters of Allah. The Arabs placed more emphasis on these three female divinities than on the five idols given to them by 'Amr Ibn Luhaij in Noah's time. For example, the Quraysh, the tribe to which the Prophet Muhammad belonged, used to circle the Ka'bah saying,

> In the name of al-Lat, in the name of al-'Uzza, and Manah the third, the different ones! They are the highest of all swans, and one may hope for their intercession with God!

The idols Manah, al-Lat, and al-'Uzza were regarded as mediators with God. They were compared to cranes flying high in the sky.

Manah

Manah was the oldest of the three idols. The Arabs used to add appendages to form the names 'Abd-Manah (servant of the Manah) and Zayd-Manah (friend of the Manah). Manah was considered the goddess of fate, particularly with regard to the manner of one's death. However, at the time of Muhammad, Manah had the least significance of the three goddesses and was subordinated to the other two. In earlier times, Manah might have had greater significance in Hejaz, the Arabian seashore at the Red Sea, but later was overshadowed by al-'Uzza. The idol of Manah was a black, deformed stone. It stood erect at the seashore between Mecca and Medina in the area of the mountain al-Mudallal in Qudaid. All Arabs worshipped Manah. When animals were sacrificed in honor of Manah, the animal's throat was cut, and the blood was spread over the stone.

No tribe worshiped those idols more than the Aws and the Khazraj. Both these tribes, as well as others arriving from different cities to worship Manah, still carried out the Hajj. Like other worshippers, they observed the individual stops of the pilgrimage, yet in addition to worshipping the idol, they also cut their hair.

The Quraysh worshipped Manah until eight years after the Hajj, when the Prophet and his followers fled from Mecca to Medina. At that point, Muhammad sent his son-in-law, 'Ali to destroy the idol. Afterwards, 'Ali removed the objects that were meant as sacrifices. Then, he returned to the Prophet. Among the objects he removed were two swords which the king of Gassan, al-Harith ibn-abi-Shamir al-Ghassani had dedicated to Manah. One of the swords was called Mikhdham, and the other one was called Rasub.

According to another tradition, 'Ali found the two swords in the hollow of the idol al-Fals. The idol, which belonged to the tribe of the Taiji', was a red ledge in a black mountain called Aja' and resembled a human statue. The idol was destroyed by 'Ali at Muhammad's behest.

al-Lat

Al-Lat is the female form of the designation "Allah" and means "the goddess." The cult of this goddess existed for more than a thousand years before Islam. al-Lat was known in peripheral areas such as Palmyra, an oasis in the desert of Syria. The people of Nabatea also knew al-Lat. These people often mixed different parts of Arabic and foreign religions.

Al-Lat's idol was a rectangular rock located in at-Ta'if. Its custodians were the descendants of 'Attab Ibn Maliks of the Thaqif tribe. They had built an edifice, ostensibly a house, above it. It was covered, as was the Ka'bah in Mecca, with a blanket. Al-Lat was worshipped by the Quraish and by all other Arabs. The names "Zayd al-Lat" (friend of the Lat) and "Taym al-Lat" (slave of the Lat) were based on this idol. The idol itself was placed at the spot where today we find the minaret that is part of the ruins of the mosque of at-Ta'if. The worship of al-Lat remained in effect until the Thaqif tribe converted to Islam. Then, the idol was burned.

Al-Lat was supposed to have been a heavenly divinity, specifically, a sun goddess. Originally, however, she was also considered identical to the goddess al-'Uzza. This idol had an astral character and was preceded by a stone cult.

al-'Uzza

Al-'Uzza is considered the youngest of the three idols. The name "al-'Uzza" is the female form of al-A'azz, one of the Ninety-Nine Most Beautiful Names of God mentioned in the Koran. Translated, the names mean "most powerful" or "mightiest." The guardians of al-'Uzza were the descendants of Shayban ibn-Jabir; the last custodian was Dubayyah.

Al-'Uzza's image was located in a valley north of Nakhla, in an area named Hurad, which was close to Mecca.

Al-'Uzza was a Samura tree, above which a house was built. At the tree's side, a holy stone was placed. This probably served as a sacrificial stone and hinted at the holiness of the tree.

The Arabs gave their children names such as 'Abd al'Uzza (servant of Uzza). Al-'Uzza was the highest idol of the Quraysh tribe. This tribe had also created a holy area in a mountain ravine of the valley Wadi Hurad—as a counterpart to Haram, the holy area of the Ka'bah in Mecca. Al-'Uzza was given gifts and sacrifices, including prisoners and children.

As with al-Lat, al-'Uzza was supposed to have been a star divinity before stone cults were fashionable. Al-'Uzza was identified with the planet Venus. The worship of al-'Uzza lasted until the Prophet Muhammad prohibited the idol cult. This prohibition was especially burdensome to the Quraysh.

Muhammad's influential uncle was known as Abu Lahab ("Father of Flames") because of his temper. He and his wife belonged to the greatest enemies of early Islam.

When Muhammad called upon his tribe, the Quraysh, as well as his own family to free themselves from idol cults and

polytheism, he was cursed by Abu Lahab with the words, "May you fall into the arms of death." This is the basis of Surah 111 of the Koran:

Perish the hands
Of the Father of Flame!
Perish he!
No profit to him
From all his wealth,
And all his gains!
Burnt soon will he be
In a fire
Of blazing flame!
His wife shall carry
The (crackling) wood
As fuel!
A twisted rope
Of palm-leaf fiber
Round her (own) neck!

(Surah 111)

"To carry firewood" may symbolize carrying tales between people. Abu Lahab died consumed with grief and full of passionate spite one week after the battle of Badr, which the pagan Arabs had lost.

After the conquest of Mecca in 630 A.D., the Prophet Muhammad gave orders to his general Khalid Ibn-al Walid to destroy the idol portrayal of al-'Uzza.

According to the legend, al-'Uzza was a demon that lived in three Samura trees in the valley of Nakhla:

When Khalid Ibn-al Walid had chopped down the first tree, the Prophet asked him whether he had seen something. Khalid replied that he had not, and thus the Prophet asked him to chop down the second tree. When he finished chopping down the second tree, the Prophet asked him again, and again he said that he had not seen anything. When Khalid Ibn-al Walid approached the last tree, he suddenly saw a witch with wild hair. She was grinding her teeth, and her hands were folded behind her neck. Beyond her stood Dubayyah, her guardian. When Dubayyah caught sight of Khalid, he called:

> *"O 'Uzza, thrust yourself heftily on Chalid,*
> *do not disappoint!*
> *Throw the veil away and arm yourself!*
> *For if you do not kill Chalid,*
> *Thus you will quickly fall into shame;*
> *Therefore, help yourself!"*

> *Yet Chalid answered:*

> *"O 'Uzza may disavowal,*
> *honor be not yours!*
> *I see that Allah has consecrated you with shame!"*

Upon hearing these words, Khalid thrashed away at the witch and split her head. Her remains turned into dust. Then he chopped down the tree and killed Dubayyah, al-'Uzza's guardian. He returned to the Prophet and reported to him what had happened. The Prophet said:

"This is al-'Uzza!
After her, there will be no more 'Uzza for the Arabs!
From this day on, she will never be worshipped again!"

Hubal

The statue of Hubal stood above the pit within the Ka'bah. This idol was made of red carnelian. It was shaped liked a human, and the right hand was broken. The Quraysh had acquired him and had manufactured a hand of gold.

In front of Hubal, there were seven Arrows of Fate, otherwise known as Oracle Arrows (al-Azlam). Such arrows had neither pointed ends nor feathers. They were considered holy and were kept by the temple custodian. On one of these arrows was written "sahih" (pure, from pure blood); on another one was written "mulsaq" (stuck to, pasted on, foisted upon). If a man doubted the legitimacy of a newborn child, he consecrated a sacrificial animal to Hubal. The oracle arrows were shaken. If the word "sahih" appeared, the child was accepted as the proper, natural child. However, if "mulsaq" appeared as the answer, the child was rejected. In addition to these two arrows, there were also arrows that concerned the dead and that symbolized a wedding.

When pagan Arabs were undecided about a matter, such as whether or not to go on a trip, they went to Hubal in order to throw the oracle arrows in front of him. The decision or action they took was always based on the "advice" of the oracle arrow.

The grandfather of the Prophet Muhammad also stood in front of Hubal. He had sworn that if he were ever the father of ten sons, he would sacrifice one of them to God in front of the Ka'bah. 'Abd al-Muttalib finally became the father of twelve sons and six daughters. When ten of his sons had grown up, he announced his vow to them and had their names written on ten arrows of fate. Sahib al-Azlam, the temple custodian was given

the order to mix the arrows and to draw one of them. Destiny fell upon Abdallah, the father of the Prophet. 'Abd al-Muttalib led his son Abdallah to the idols Isaf and Na'ila, the usual sacrificial place, not far from the Ka'bah. There, he took his knife and raised his hand in order to kill him. However, the members of his tribe, prevented him from doing so.

Isaf and Na'ila

The pagan Arabs believed these two idols were human beings who had been turned into stone. (The Arabs regarded many stones and rocks as metamorphosed human beings.) According to tradition, the idols were a man and woman from the Yemenite tribe of Jurhum. They were called Isaf Ibn Ya'la and Na'ila Bint Zayd.

Isaf fell in love with Na'ila. Both came as pilgrims to Mecca and entered the Ka'bah. They found a lonely spot in the temple where they were hidden from view. There, Isaf fornicated with Na'ila in the holy house. They were both turned into stone. When they were found the next day, they were carried outside and were set up at the Ka'bah as a warning. These two stones were worshipped with the other idols. One of the stones was placed right next to the Ka'bah; the other one was set up at the spring of Zamzam. Finally, the Quraysh ordered that the stone next to the Ka'bah to be carried to the other one at Zamzam. From then on, people slaughtered their sacrificial animals at that spot.

Dhu 'l-Khalasa

This idol was located in Tabala between Mecca and Yemen. It was a white stone with a white crown chiseled on it. The descendants of the Umama from the Bahila Ibn A'sur clan were the custodians. The Khath'am, the Bajila, Azd as-Sarat, and the neighboring Arabic tribes of Hawazin worshipped it and brought sacrifices.

Three Oracle Arrows belonged to the idol Dhu 'l-Khalasa. The first arrow was al-Amir (ordering), the second one an-Nahi (forbidding), and the third one al-Mutarabbis (waiting and seeing).

Imra'-al Qays shook the Arrows of Fate three times in front of Dhu 'l-Khalasa after his father, Hujr, was killed by the descendants of the Asad tribe. Imra'-al Qays was questioning the idols about the intended blood revenge on the Asad tribe. Every time he asked, he pulled the forbidding arrow. He was so furious that he broke all three arrows and struck the idol with the broken pieces. He cursed the idol, "May you bite the limb of your father! If your father had been murdered, you would not have held me back." Then he attacked the Asad tribe and conquered it.

The Oracle Arrows of Dhu 'l-Khalasa were never used for questions again. When Islam was revealed, the idol was destroyed. Imra'-al Qays was the first to renounce the idol Dhu 'l-Khalasa.

The stony remains of this idol form the threshold of the Tabala mosque. According to a statement by the Prophet Muhammad, the end of the world will not occur until the backsides of the women from the Daus tribe hit each other the way they did when they worshipped Dhu 'l-Khalasa in earlier times.

'Amm-Anas

The idol 'Amm-Anas belonged to the Yemenite tribe of Khawlan.
He was one of the idols mentioned in Surah 6.136 of the
Koran:

Out of what God
Hath produced in abundance
In tilth and in cattle,
They assigned Him a share.
They say, according to their fancies,
"This is for God, and this
For Our partners'!"
But the share of their "partners"
Reacheth not God, whilst
The share of God reacheth
Their "partners"! Evil
(And unjust) is their assignment!

(Surah 6.136)

As soon as the pagan Arabs had brought in their harvest, they
shared one part with God and the other one with their idol.
When the wind came from the direction of the share that they
had given to their idol and carried some of it over to that which
was meant for God, they returned the share to their idol. If,
however, the wind came from the direction of the share that was
meant for God and carried some over to the idol, they left it as
it was and did not put anything back.

Star Myths and Star Cults

Astrology reached a significant level in the Middle Ages, well after the revelation of the Koran. At this time, people endeavored to explore the descriptions contained in the Koran about the universe, the planetary systems, and other aspects of nature. The people in the Christian Occident also profited from the knowledge of the Koran and its followers.

The Bedouins probably already knew about single constellations and their movements, but they did not have any linked knowledge about the entire solar system.

Stars were considered living beings that influenced the lives of humans and of animals. They had a particular influence on the weather, that is to say "weather" in a very broad sense. Thus, the word "anjama" (in the stars) meant that there was a change of weather coming. Names of stars were also used as names for people, for example, Venus (Zuhara) and Mercury ('Utarid).

Because people thought of stars as human beings, the star myths that followed had no religious character, and they cannot be regarded as a star cult. Thus, for example, there exists from the pre-Islamic period a central Arabic tale about the Great Bear, the Little Bear, the North Star, and Canopus:

> 'Ali al-Mansur related the tradition of the "daughters of the bier" (the seven stars of the Great Bear). In the past, the kid, or baby goat (the North Star), courted one of the daughters with her father. The kid grabbed and robbed her. However, it was afraid of her father, and so it killed him and looked for protection with the stars of al-Hayaischin, "the small defending ones" (the

stars Beta and Gamma of the Little Bear). The sisters carried their father away on the bier, buried him, and traveled on with their bier because they wanted to kill the kid in revenge for their father and the robbery of their sister. When they arrived and wanted to grasp him, he said, "O you who are traveling at night, I am not the one to blame. The one to blame is Suhail (Canopus)."

They looked for Suhail. He came towards them from far away and said, "O you who are traveling at night, I am not the one to blame; the one to blame is the kid."

The sisters returned once more to the kid, but the stars of al-Hayaischin stepped in front of him and released him because he was their companion. This is still the task of al-Hayaischin.

On the other hand, some single fixed stars and planets enjoyed religious worship. Thus, the Himyarites were supposed to have honored the sun; the Kinana tribe, the moon; Tasm, ad-Dabaran, Lakhm, and Judham, Jupiter (al-Mushtari); Taiy, Canopus (Suhail); Quais, Sirius (ash-Shi'r al-'abur); and Asad, Mercury ('Utarid). Unfortunately, we have no details about these cults.

However, the Venus cult is regarded as verifiable in connection with the goddesses al-Lat and al-'Uzza, so we can assume the existence of a stone cult and an original star cult for these two idols.

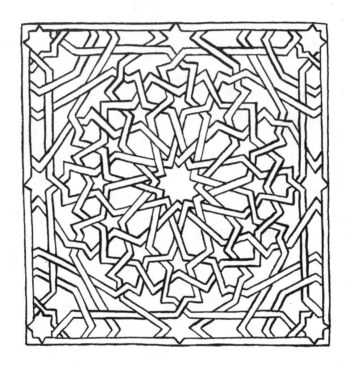

The Belief in Spirits

In the pre-Islamic period, the jinn (spirits, demons) were worshipped by the descendants of Mulaih of the Khuza'a tribe. The Koran revealed the following about the worship of the jinn:

Do they indeed ascribe
To Him as partners things
That can create nothing,
But are themselves created?

(Surah 7.191)

Verily those whom ye
Call upon besides God
Are servants like unto you . . .

(Surah 7.194)

Yet they make
The jinns equals
With God, though God
Did create the jinns;
And they falsely,
Having no knowledge,
Attribute to Him
Sons and daughters . . .

(Surah 6.100)

On the other hand, pagan Arabs often claimed that angels were the daughters of Allah whom he sired with the noblest jinn women:

> *And they have invented*
> *A blood-relationship*
> *Between Him and the jinns,*
> *But the jinns know*
> *(Quite well) that they*
> *Have indeed to appear*
> *(Before His Judgment Seat)!*

(Surah 37.158)

According to the pagan Arabs, the jinn were not pure spiritual creatures. They were also not made of flesh and blood. They were usually considered invisible, yet somehow physical beings. Thus, human needs, such as eating and drinking, were attributed to them. They were also considered vulnerable. Differences existed between male and female spirits, and they could reproduce themselves with human partners and have descendants. They were even divided into clans and tribes, depending on the organization of Arabic families and the tribal associations at this time. We are not dealing with the spirits of the deceased, but with spirits of nature whose existence has to be considered as something independent of human beings.

Most frequently, the jinn appeared in the shape of animals, particularly animals from the wilderness or in the form of pets. Animals such as panthers, jackals, wild cats, donkeys, and dogs played major roles, as did birds such as ravens, owls, green woodpeckers, hoopoes, and ostriches. Above all, however, archetypes for demons were recognized in snakes and other crawling animals such as lizards, scorpions, and beetles. However, demons

were not tied to a particular form, and they could freely change their shape.

In addition to residing in the desert, demons were also found in areas that were difficult to access and in places of decay such as old ruins. Cemeteries were also considered popular places of residence. For example, the creature Ghoul, a cannibal, was pictured as a monstrous demon. According to folk wisdom, he is still rampaging in the desert.

Because people believed that spirits resided in the ground, they offered up a sacrificial animal when constructing a house, digging a well, cultivating fallow land, and beginning other similar projects. People sprinkled the blood of the sacrificed animal on the chosen place in order to avoid the wrath of the spirits.

Additional spirits were said to live in trees and bushes, and they were also said to exist as household spirits in people's residences.

The works and deeds of the jinn were regarded as unfathomable and caused terror among the people. In addition, these demons were seen as the cause of diseases, particularly of fever and epilepsy. Thus, the designation for a madman was a "Majnun," meaning possessed by a jinn.

In addition to the concept of these negative, molesting spirits, people also believed in the concept of positive and friendly spirit inhabitants or a similar beneficial and close relation between a human being and a jinn. People believed that every person had a double among the jinn. Perhaps they even believed in a personal guardian spirit. Certainly, however, people believed that favored individuals had close and amiable relationships with the jinn. In particular, the soothsayer was supposed to have been inspired by beings (Kahin) to whom the jinn confided their secret knowledge. People also assumed such sources of inspiration for poets

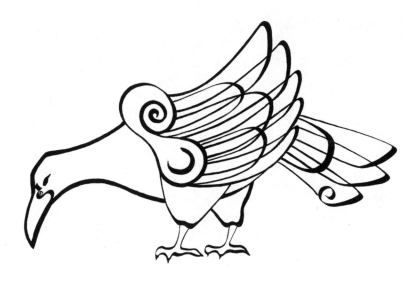

The raven was a pre-Islamic symbol of death and separation.

and musicians, which contributed to their high respect in pre-Islamic Arabia.

All in all, however, the jinn were rather unpleasant to human beings. They were capriciously useful or harmful to people. Due to their unpredictability, one tried to avoid contact with them. This required the use of different kinds of offensive measures. For example, people were not permitted to whistle or play the flute because they assumed that the spirits called each other through those tones. Imitating one of the animals that were regarded as popular shapes of the jinn was considered a protective measure as was carrying an amulet. In addition, people tried to appease the jinn with sacrificial rites.

The numerous magical incantations of the Arabs often contained a summoning of the jinn; furthermore, the malicious look of the envier and that of the admirer were seen as the look of the jinn.

The origin of this rich belief in spirits is found among settled people in villages since the loneliness of the desert is something mundane and commonplace for the Bedouins. On the other hand, everything outside the city or village was foreign and frightening for those inside city walls. The same is true today. The intensity of belief in spirits is far greater among people in villages or in urban areas than among the Bedouins.

A knot pattern.

Magic, Soothsaying, Omens, and Amulets

At the time of the Prophet Muhammad, there were soothsayers who claimed to be able to see happenings from both the past and the future due to their intimate relationships with the jinn and other secret sources.

Besides questioning the Oracle Arrows, other methods were used to ascertain the future. In addition, there were diverse omens that led to certain patterns of behavior. The most important were the evil omens, which were looked for in almost all happenings, places, objects, and people.

Most frequent were the prophecies based on animal behavior. An animal coming from the right was regarded as a good sign; on the other hand, an animal coming from the left was a bad omen. Generally, there was a distinct symbolism around the terms "right" and "left." Thus, for example, the right hand was a symbol for power and strength. Therefore, an honored guest was always seated to the right of the host. "Right" and "left" became synonymous with "happy" and "unhappy."

This symbolism was also used in the interpretation of the flights of birds. The hoopoe, the owl, and especially the raven played a special role in connection with prophecies because these birds were regarded as preferred shapes of the jinn.

Thus, the raven was the bird of ill omen. It foreshadowed death, but above all else, it represented an imminent separation from friends and lovers.

In conjunction with magic, deliberate measured breathing, knots, and humming were regarded as incantations for spirits. Knotting or creating knots was regarded as a love charm with

which one attempted to tie the lover to one's own person. The charm for making demons harmless was also very popular. Thus, for example, rabbit's ankles, worn as amulets around the neck, were supposed to protect against demonic influences of any kind.

When the Prophet Muhammad triumphed on the day when Mecca was conquered, he entered the mosque. Before him were the idols set up around the Ka'bah. He began to thrust into their eyes and faces with the horn of his bow:

> *And say, "Truth has (now)*
> *Arrived, and falsehood perished,*
> *For falsehood is (by its nature)*
> *Bound to perish."*

<div align="right">(Surah 17.81)</div>

PART TWO

Islam

A Koran stand, used to protect the Koran

The Revelation

Proclaim! (or read!)
In the name
Of thy Lord and Cherisher,
Who created man, out of
A (mere) clot
Of congealed blood.
Proclaim! And thy Lord
Is Most Bountiful,
He Who taught
(The use of) the pen,
Taught man that
Which he knew not . . .

(Surah 96.1–5)

These verses were the first revelation bestowed on the Prophet in the year 610 A.D. Muhammad was forty years old at the time. The angel Gabriel (Jibril) brought them to him one night towards the end of Ramadan. He had retreated for prayer and meditation into the mountain cave Ghrar Hira' (Grotto of Exploring) of the Jabal al-Nur (Mountain of the Light). Muhammad himself was so shocked and frightened about this event that he only entrusted this revelation to his wife, Khadija.

The revelation of the individual Surahs of the Koran happened in a fragmentary fashion over a period of twenty-three years until Muhammad died. For thirteen years of those years, he was in Mecca; for ten years, he was in Medina. Some Surahs, or verses, refer to specific problems or situations at that time, such as the two armed conflicts between Badr and Uhud. This also

explains why some of these Koran verses have an aggressive tone. Regrettably, these particular verses seem to attract the attention of Western journalists. In order to understand the text of the Koran, one must have a knowledge of the historical background of the respective revelation (Asbab al-Nuzul).

Muhammad himself could neither read nor write, so he passed the revelations orally to helpers. Like Muhammad, these vassals or followers learned the verses by heart and wrote them down. After the death of the Prophet, Zaid Ibn Thabit, the chief scribe during the last years of Muhammad's life, was instructed by the Caliph Abu Bakr (632–634 A.D.) to duplicate all the revelations in the form of a book. This scribe belonged to the Hafiz in Medina. They were the people who knew the entire Koran by heart. However, the Caliph ordered him to find two written records for each verse before he was allowed to begin the final summary. The people of Medina brought him records of single partial revelations they held in their possession. The "official" transcriptions were written on parchment, leather, silk, and papyrus; however, notes were also inscribed on stones or palm leafs. Only two Koran verses are supposed to have been based on the written tradition of a single man. This duplication of the complete revelations is called Mushaf (collected sheets) and was deposited with the Caliph Abu Bakr.

Under the Caliph Othman (644–656 A.D.), seven copies of the Koran were produced for the different centers of the empire. This allowed people to check the faithfulness of the copies to the original. Whatever did not match the duplicate was destroyed. One of these seven copies is still intact; it can be found in Tashkent.

The Koran is divided into 114 Surahs. The Surahs revealed in Mecca are older than the ones from Medina. The order of the Surahs, however, does not correspond to the chronological order of the revelations themselves. Whether a Surah was revealed in Mecca or Medina is only hinted at in the transcripts. The Koran approaches issues that are relevant to society and that concern ethical as well as legal matters. Based on these issues, the Koran evaluates the historical experiences of humankind and the connections between behavior and the prospering or perishing of a civilization. The theological and spiritual statements repeat the request to think of God's presence in Creation and to take the necessary steps for one's own belief and actions. The names or titles of individual Surahs were not part of the original text that was revealed; they were added later. These names indicate the topic or focus of the Surah.

For Muslims, the Koran is the word of God revealed through the angel Gabriel to his Prophet Muhammad. The Sunnah, the collection of Hadiths, is another basis of practicing faith. The Muslims following the Sunnah are called Sunnites; Shi'itic Muslims derive their practice from the Sunnah and from the Shi'ah, the party of 'Ali. 'Ali was the son-in-law of the Prophet Muhammad. The adherents of Shi'ah are called Shiites. They follow a rite that deviates from the one of the Sunnah. Shiites are generally referred to as an Islamic cult which itself is divided into various subgroups. The Shiites represent fifteen percent of the Muslim world.

The Sunnah and the Koran are complementary in that the statements and conduct of the Prophet were passed on to the Hadiths. The Hadiths can be compared with the Gospels of the New Testament that contain the life of Jesus. The basic difference

lies in the fact that the Hadiths had to show a complete chain of proof in order to be considered plausible. Strict standards were applied for the proof. The people who transmitted the Hadiths had to be flawless in their belief and religious behavior; furthermore, they had to have been accepted without question by other Muslims. In addition, they had to have been considered trustworthy, and they had to prove that they had properly understood the oral statements or actions of the Prophet and had passed them on correctly. They also had to have passed on more than one Hadith. Finally, the Hadith had to have a content that fitted into the scope of the first community.

When all these criteria were fulfilled, the respective Hadith was assessed as real or authentic (sahih). In addition, the so-called nice Hadiths (basan) are known in the Islamic theology but are not perfectly reliable. There are also the weak Hadiths (da'if), the plausibility of which are viewed with great doubts.

Muhammad himself never claimed to be pronouncing a new religion. This is evident in many places in the Koran:

It is He Who sent down
To thee (step by step),
In truth, the Book
Confirming what went before it;
And He sent down the Law
(Of Moses) and the Gospel (Of Jesus) before this,
As a guide to mankind, And He sent down the Criterion (Of judgment
between right and wrong).

(Surah 3.3)

Like all prophets, Muhammad was the bearer of a message and a warning:

> *Muhammad is no more*
> *Than an Apostle; many*
> *Were the Apostles that passed away*
> *Before him . . .*

(Surah 3.144)

> *Say, "I have no power*
> *Over any good or harm*
> *To myself except as God*
> *Willeth. If I had knowledge*
> *Of the unseen, I should have*
> *Multiplied all good, and no evil*
> *Should have touched me.*
> *I am but a warner,*
> *And a bearer of glad tidings*
> *To those who have faith."*

(Surah 7.188)

Because of this clear definition of Muhammad's task, Muslims reject the term "Muhammadans" since the term conveys the impression that their faith is based on a person. The word "Muslim" means that the follower submits himself to God and to God's will alone.

Calligraphy of Surah 112 (Al-Ikhlas, The Purity of Faith)

Faith

Say, He is God
The One and Only
God, the Eternal, Absolute;
He begetteth not,
Nor is He begotten;
And there is none
Like unto Him.

(Surah 112, Ikhlas, Purity of Faith)

There is no god but He.
That is the witness of God, His angels, and those endued With knowl-
edge, standing firm on justice. There is no god but He, the Exalted in Power,
the Wise.

(Surah 3.18)

God! There is no god but He,
the Living, the Self-subsisting, Eternal.
No slumber can seize Him nor sleep.
His are all things
In the heavens and on earth.
Who is there can intercede
In His presence except
As He permitteh? He knoweth what
(appeareth to His creatures as)
Before or after
Or Behind them.
Nor shall they compass
Aught of His knowledge
Except as He willeth.
His throne doth extend

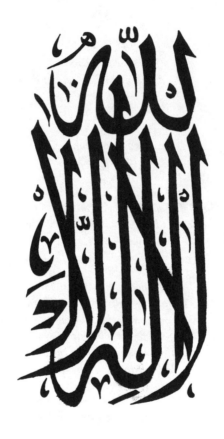

Calligraphy of the creed : "La ilaha ill-Allah" (Nothing deserves to be worshipped except Allah).

Over the heavens,
And the earth, and He feeleth
No fatigue in guarding
And preserving them
For He is the Most High,
The Supreme (in glory).

(Surah 2.255, Ayat-ul-Kursi, the Throne Verse)

The Tauhid, the belief in the existence and singularity of God, is the actual core of Islam and should be protected by all Islamic doctrines and laws (Al-Shari'ah). Thus, the Tauhid is also the content of the Shahadah, the Islamic creed that constitutes the first of the so-called five pillars of Islam. The Islamic creed is pronounced in the presence of two Muslim witnesses and reads as follows:

> Ashhadu an la ilaha ill-Allah wahadahu la sharika lahu wa ashhadu anna Muhammad-an Rasulu-llah. (I bear witness that nothing deserves to be worshipped except Allah, Who is without partner, and I bear witness that Muhammad is the Apostle of Allah and his Prophet.)

> "Islam" itself means devotion and is usually translated as "the peace-making submission to God's will." The other pillars are the daily chores of the five prayers (as-Salah), donations to the needy (Zakat), fasting in the month of Ramadan, and the pilgrimage to Mecca (Hajj).

> In Islamic theology, God is understood as absolutely transcendental and outside any physical perception. At the same time, however, he is omnipresent as well as omnipotent as the following verses emphasize:

Calligraphy: "Allah."

No vision can grasp Him,
But His grasp is over
All vision . . .

(Surah 6.103)

It was We who
Created man, and We know
What dark suggestions his soul
Makes to him, for We
Are nearer to him
Than (his) jugular vein.

(Surah 50.16)

In addition to believing in the existence and uniqueness of God, Islam also believes in the revealed books of God, his prophets, predestination, the existence of angels (as well as the existence of the jinn and of Satan), the Last Judgment (eschatology), and Resurrection after death.

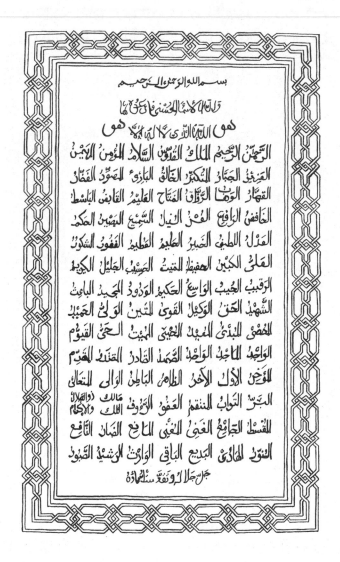

The ninety-nine most beautiful names of God.

The Ninety-Nine Most Beautiful Names of God

Islamic mystics are called Sufis or dervishes, and these are subdivided into different groups called orders. The Islam mystic Al Hallaj (executed in 913 A.D.) dictated the following sentences to one of his students:

Truly God is holy and sublime, to Whom praise is due. He is an essence existent through His prehistory, isolated from that which He is not, singled out from that what is beside Him, through absolute Lord-Being. Nothing mixes with Him and nothing else mingles with Him; no place contains Him and no time grasps Him; no thought can assess Him, and no imagination imagine Him, no glance reaches Him and no slackness catches Him ... My son, guard your heart to think of Him, and mind your tongue to remember Him; yet use the two to always thank Him. For to think about His nature and to imagine His attributes as well as confirm Him with words, belongs to the mightiest sins and the greatest haughtiness.

As the Koran points out, the ninety-nine most beautiful names of God do not explain or define the nature of God; the absolutely transcendental God cannot be grasped via human perception, let alone be described. God is not only the single One externally, but internally as well. His nature does not split into several characteristics or else the inner multiplication of God's nature would inevitably lead to the outer multiplication. This would result in polytheism (multiple deities).

Hinduism is an example of the division of divine characteris-

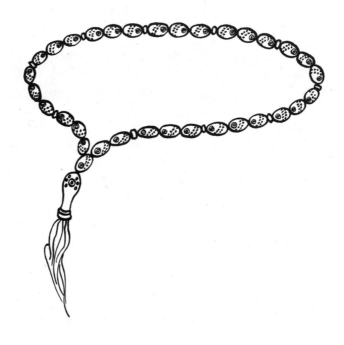

The Misbaha is a string of thirty-three or ninety-nine pearls. It serves as an aid for the recitation of the ninety-nine most beautiful names of God.

tics. Hinduism is polytheistic: Brahma is regarded the creator, Vishnu the preserver, and Shiva the destroyer. This is a reduction of the respective functions.

In contrast, the ninety-nine most beautiful names of God symbolize the characteristics of one single God. Through the revelation of his names, that is to say his characteristics, God makes himself known to man. Yet even though he makes himself known, God's nature remains hidden:

> *He is the First*
> *And the Last,*
> *The Evident*
> *And the Immanent*
> *And He has full knowledge*
> *Of all things.*

(Surah 57.3)

The single names that can be found spread throughout the entire Koran are as follows:

Allah, Al-Rahman (the Benefactor or the Compassionate); Al Rahim (the Merciful); Al-Malik (the King, the Sovereign Lord); Al-Kuddus (the Holy); As-Salam (Peace); Al-Mu'min (the Preserver of Faith, Source of Security and Protection); Al-Muhaymin (the Vigilant); Al'Aziz (the Powerful and the Precious); Al-Djabbar (the Very Strong, the Oppressor); Al-Mutakabbir (the Haughty, the Great); Al-Khalik (the Producer, the Creator of Things); Al-Bari (the One Who Produces from Nothing); Al-Musawwir (the Organizer); Al-Ghaffar (the Indulgent, the Pardoner); Al-Kahhar (the Dominator, He Who always subdues, dominating and never

dominated); Al-Wahhab (the Constant Giver); Al-Razzak (the
Dispenser of All Good); Al-Fattah (the Victorious, the Revealer,
the Judge); Al-'Alim (Knowing Everything, Attribute of
Knowledge); Al-Kabid (Restrainer, the Refuser); Al-Basit (the
Granter, the Multiplier, the Expander);
Al-Khafid (Who humbles and humiliates); Ar-Rafi' (He Who
raises in Dignity); Al-Mu'izz (He who gives Honor and
Strength); Al-Mudhill (Who abases and degrades); Al-Sami'(the
Hearer of Everything, the Hearer); Al-Basir (the Seer of
Everything, the Perceiver); Al-Hakam (the Judge); Al-'Adl (the
Just, the Balancer); Al-Latif (the Noble, the Benevolent);
Al-Khabir (the Sagacious); Al-Halim (Endowed with Gentleness,
He who is slow to punish); Al-'Azim (the Inaccessible, the
Immense); Al-Ghafur (the Very Indulgent); Al-Shakur (the Very
Grateful, the Repayer of Good Deeds); Al-'Ali (the High,
the Sublime); Al-Kabir (the Great); Al-Hafiz (the Preserver, the
Protector, the Vigilant Guardian); Al-Mukit (the Nourisher,
the Source of Strength); Al-Hasib (the Calculator); Al-Djalil (the
Majestic); Al-Karim (the Benevolent, the Generous); Al-Rakib
(the Vigilant, the Guardian); Al-Mudjih (the Assenter, He Who
listens to Prayers); Al-Wasi' (the Omnipresent, He Who
Embraces and contains All Things, the Immanent); Al-Hakim
(the Wise); Al-Wadud (the Very Loving); Al-Ba'ith (the Reviver
of the Dead); Al-Shahid (the Witness); Al-Hakk (Truth); Al-Wakil
(the Trustee, the Lawyer, the Representative); Al-Kawi (the
Strong); Al-Matin (the Unshakable, the Solid); Al-Wali
(the Protective Friend, the Patron); Al-Hamid (Worthy of Praise);
Al-Muhsi (the Bookkeeper, the Calculate); Al-Mubdi'
(the Innovator, the Procreator); Al-Mu'id (He Who resuscitates,
He Who restores); Al-Muhyi (the Creator of Life); Al-Mumit (the

Creator of Death; the Destroyer); Al-Hayy (the Eternally Living; the Self-Preserver); Al-Kayyum (the Eternal, the Self-Subsisting); Al-Wadjid (the Opulent, the Noble); Al-Madjid (the Glorious, the High); Al-Wahid (the Unique); Al-Ahad (the One), Al-Samad (the Eternal Help for Creation); Al-Kadir (the Powerful, the Talented); Al-Muktadir (the All-powerful); Al-Mukkadim (the Transporter, the Driving Forward); Al-Mu'akhkhir (the Delayer, the Preventer, the Changer); Al-Awwal (the First); Al-Akhir (the Last); Al-Zahir (the Manifestly Dominating, the Patient); Al-Batin (the Hidden, the Latent); Al-Wali (the Reigning); Al-Muta'ali (the Very High, the Exalted); Al-Barr (He who causes Piety); Al-Tawwab (the Repentant); Al-Muntakim (the Avenger); Al-'Afu (the Forgiver, the Concession Maker, the Benevolent); Al-Ra'uf (the Merciful, the Compassionate); Malik al-Mulk (the Holder of Sovereignty); Dhu'l-Djalal wa'l-ikram (the Lord of Majesty and Generosity); Al-Muksit (the Just); Ad-Djami' (the Collector, the Assembler); Al-Ghani (the Rich, the Independent, He Who Lacks Nothing); Al-Mughni (the Enricher); Al-Mani' (the Tutelary Defender, the Preventer); Al-Darr (He Who afflicts); Al-Nafi' (The Helper, He Who Favors); Al-Nur (the Light); Al-Hadi (the Guide); Al-Badi' (the Creator-Inventor, the Incomparable); Al-Baki (He Who lasts without End, the Eternal); Al-Warith (the Inheritor); Al-Rashid (the Leader Who leads on the way to Good, the Guide); Al-Sabur (the Very Patient).

The single characteristics, or names, are identical and equal to each other. The most popular names are "The Benefactor" and "The Merciful" (Al-Rahman, Al-Rahim). The Egyptian mystic Dhu'n-Nun (died 859 A.D.) was once asked what was the greatest name of God. Dhu'n-Nun answered, "Show me the smallest!"

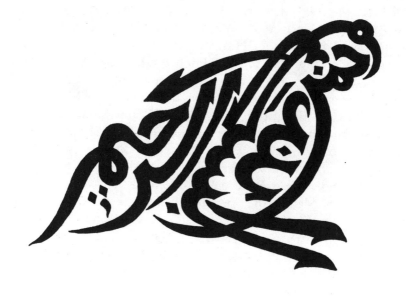

Calligraphy: A eulogy in the form of a bird ("Bismi'llahi'r-Rahmani 'r-Rahim")

and threw the questioner out.

The ninety-nine most beautiful names are recited in order to meditate about the nature of God. The only aid with the recitation or devotion (Dhikr) is the Misbaha, a string of thirty-three or ninety-nine pearls made of wood, glass, or plastic. The Misbaha originated in India where it was also used by Hindus and Buddhists to aid devotions. Because it is used for a similar purpose, the Misbaha can be compared with the rosary used by Catholics.

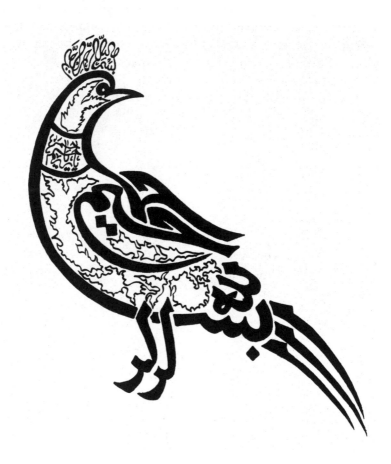

Calligraphy: "Bismi'llahi'r-Rahmani 'r-Rahim" in the form of a peacock.

Icons

Considering Islam's strict monotheism, the issue of an icon has logical consequences. Often the prohibition against the use of an icon is only connected with Islam (Islamic Icon), but it is also part of the Ten Commandments of Judaism and Christianity: I am the Lord thy God who brought you out of the land of Egypt, out of the house of bondage.

> Thou shalt not have other gods before me. Thou shalt not make unto thee a graven image, nor any manner of likeness, of any thing that is in heaven above, or that is in the earth beneath, or that is in the water under the earth; thou shalt not bow down unto them, nor serve them...
>
> (Exodus 20.2-5).

Both the strict belief in one transcendental God and the prohibition against icons resulting from that belief are not new. Yet many leaders of Islamic countries seem to have forgotten the prohibition. Instead, they have themselves depicted as idols in a kind of socialistic cult of personality. In a grotesque fashion, their portraits decorate public facilities and the walls of houses. Billboards and car stickers are decorated with their images.

The concept of not creating icons is based on respect for God's creative power, which is incomparable. Whereas human beings are only able to mold or to produce something from existing materials or elements, God creates things from nothing:

To Him is due
The primal origin
Of the heavens and the earth:
When He decreeth a matter,
He saith to it, "Be,"
And it is.

(Surah 2.117)

The Koran and Hadiths emphasize this point in other verses:

See they know not how God
Originates creation, then
Repeats it, truly that
Is easy for God.
Say, "Travel through the earth
And see how God did
Originate creation; so will
God produce a later creation,
For God has power
Over all things."

(Surah 29.19–20)

He is God, the Creator,
The Evolver
The Bestower of forms . . .

(Surah 59.24)

He it is Who shapes you
In the wombs as He pleases . . .

(Surah 3.6)

Narrated by Ibn Abbas: The Prophet said, "Whoever claims to have seen a dream which he did not see, will be ordered to make a knot between two barley grains which he will not be able to do; and if somebody listens to the talk of some people who do not like him or they run away from him, then molten lead will be poured into his ears on the Day of Resurrection; and whoever makes a picture, will be punished on the Day of Resurrection and will be ordered to put a soul in that picture, which he will not be able to do."

(Hadith Number 165, Volume 9, Book 87)

Narrated by Ibn Mas'ud: He heard the messenger of Allah say the following: "Those who will receive the most severe punishment from Allah on the Day of Resurrection will be painters (of living objects)."

(Hadith, Number 5,272, Book 24)

Narrated by Abu Huraira: I heard the Prophet saying, "Allah said, 'Who are more unjust than those who try to create something like My creation? I challenge them to create even the smallest ant, a wheat grain or a barley grain.'"

(Hadith, Number 648, Volume 9, Book 93)

The primary intention of the prohibiton against icons is to ensure that human beings do not fall back into idol cults (Jahiliyyah) by praying to statues or pictures. Islam seeks to protect people from the error that any kind of power might radiate from these objects. Figures that are worshipped beside

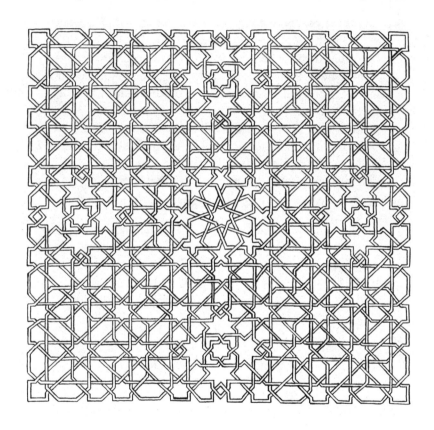

The mosaic panel from the Alhambra analyzed by Karl Gerstner.

God or instead of God are strictly prohibited. The prohibition extends to portraits and statues of prophets such as Jesus, paintings or figures of Mary, paintings of Fatima (the daughter of the Prophet Muhammad), and her husband 'Ali. Furthermore, the depiction of saints is forbidden.

Figures that are not made for worship but with the intent of imitating God's creation are not allowed. What is decisive is the intent of the artist. However, if the prohibited statues or icons were disfigured or disparaged, they were allowed. This is the case, for example, with figures on carpets or mats.

In addition, the taboo embraces statues, busts, and pictures of great personalities such as rulers, leaders, and politicians that are shown in public in order to be worshipped. According to a general understanding, statues of any kind are prohibited (haram) unless they are neither devotional nor worshipped. Dolls for children and figures made of chocolate or sugar are excluded from this prohibition because these objects do not receive any particular kind of attention or devotion. Pictures of human beings and animals to which no special attention is given are merely subject to disapproval (makruh); however, these are seen as an expression of luxury or waste.

According to a general understanding of Islamic doctrine, photography is essentially allowed among the Muslim population because it catches an image of a real being or an object. Photographs, drawings, and paintings of gender-related content and photographs of famous people that are intended for worship are not permitted. Pictures or polytheistic rituals or symbols of other religions that do not support the belief in one single God are not permitted. However anyone who does not produce

pictures to propagate disbelief (Kufr) and idol worship (Shirk) is "only" guilty of having manufactured an image (Suwar).

Clearly, Islam is opposed to symbols, although it does have some symbolic acts of its own. The basis of this opposition is that Islam tries to prevent believers from straying from monotheism in its strictest sense: the belief in one single God. Therefore, Islamic artists looked for other forms of expressing themselves besides realism or naturalism. Under Islam, abstract ornamentation and, in particular, calligraphy reached an incomparable peak. In calligraphy, one can see a reflection of the artist's love for the revealed text.

Karl Gerstner explained the concept behind Islamic art while discussing a mosaic panel. He felt that the natural inclination of Islam towards abstract ideas is expressed in non–naturalistic art. He stated that what we consider reality is nothing but the shadow of reality; that which is real lies in the divine and the spiritual. The content of Islam art reflects the latter. Islamic art does not want to present the outer creation but the inner creation, that which is eternally valid.

The Koran verses and Hadiths cited at the beginning of this section are especially relevant to the current controversy about gene technology in which one attempts to remove "bad" genes or to create a "preferred" gene. Apart from the fact that no long–term studies exist about, for example, the effects of genetically altered food, the ethical danger is already at hand. Who shall determine what a good or bad gene is? Based on the revolutionary technological progress that has already taken place, the world needs to focus its attention on the question of whether something that is technically possible may be dubious in ethical terms.

Marginal medallion for marking the end of a verse from a Koran edition in Maghrebinic writing (1560 A.D.).

Predestination

Say, "Nothing will happen to us
Except what God has decreed
For us: He is our Protector.
And on God let the believers
Put their trust."

(Surah 9.51)

No misfortune can happen
On earth or in your souls
But is recorded in
A decree before We bring
It into existence;
That is truly easy for God . . .

(Surah 57.22)

No kind of calamity
Can occur, except
By the leave of God . . .

(Surah 64.11)

Narrated by Abdullah: Allah's Apostle the true and truly inspired, narrated to us: ". . . his livelihood, his (date of) death, his deeds, and whether he will be a wretched one or a blessed one (in the Hereafter) and then the soul is breathed into him. So one of you may do good deeds characteristic of the people of Paradise so much that there is nothing except a cubit between him and Paradise but then what has been written for him decides his behavior and he starts doing evil deeds

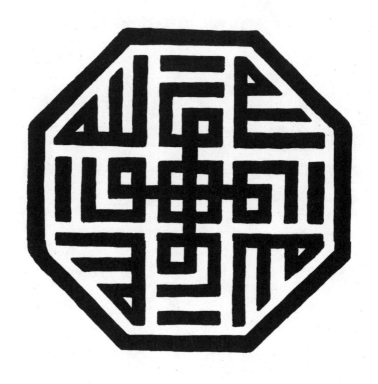

Calligraphy: "Allah."

characteristic of the people of hell (fire) and (ultimately) enters hell (fire); and one of you may do evil deeds characteristic of the people of hell (fire) so much so that there is nothing except a cubit between him and hell (fire), then what has been written for him decides his behavior and he starts doing good deeds characteristic of the people of Paradise and ultimately enters Paradise."

<div align="right">(Hadith Number 430, Volume 4)</div>

The belief in destiny and predestination (Qadar) is deeply anchored in the life of Muslims. The belief in a completely fatalistic philosophy of life without any initiative of one's own is sometimes, however, accepted by the general population. Yet this ignorant and passive attitude has its foundation not in Islam but in personal resignation.

> *. . . Verily never*
> *Will God change the condition*
> *Of a people until they*
> *Change it themselves*
> *(With their own souls). . .*

<div align="right">(Surah 13.11)</div>

Many proverbs and sayings remind us of the absolute will of God. The frequently used words, "Insha 'Allah" (God willing), indicate a person's hope that a wish or a planned purpose corresponds to God's will and, thus, will be successful. This can refer to great projects, but it also applies to relatively simple ones such as someone keeping an appointment.

Nor say of anything, "I shall be sure to do
So and so tomorrow"
Without adding, "So please God!" . . .

<div align="right">(Surah 18.23-24)</div>

Another saying that reminds us of God's omnipotence and of predestination is "La haula wa la quwwatta illa bi'llah" (There is no power, no might but from Allah). This sentence is often used by Muslims when someone suffers a misfortune, no matter whether it is a disease or other private misfortune, a business failure, or other kind of danger or adversity. This exclamation serves to remind us of the all-encompassing ruling power of God. It also helps us to become more patient and to put the situation in proper perspective. Muslims are always conscious of the fact that a situation that appears hopeless or depressing is only to be considered miserable in the context of the present situation. However, this stroke of misfortune can be regarded in the long run as a valuable personal experience or success:

. . . But it is possible
That ye dislike a thing
Which is good for you,
And that ye love a thing
Which is bad for you.
But God knoweth,
And ye know not.

<div align="right">(Surah 2.216)</div>

...but give
Glad tidings to those
Who patiently persevere,
Who say, when afflicted
With calamity, "To God
We belong and to Him
Is our return..."

(Surah 2.155–157)

Islam does not have any distinct theology of suffering. Disease and suffering are either understood as a test by God or as punishment for sins committed:

He Who created Death
And Life, that He
May try which of you
Is best in deed
And He is the Exalted
In Might, Oft-Forgiving;

(Surah 67.2)

Every soul shall have
A taste of death
And We test you
By evil and by good
By way of trial.
To Us must ye return.

(Surah 21.35)

An Persian brass plate carving (tenth–eleventh century A.D.).

Be sure we shall test you
With something of fear
And hunger, some loss
In goods or lives or the fruits . . .

(Surah 2.155)

. . . And when some evil
Afflicts them because of
What their (own) hands
Have sent forth, behold,
They are in despair!

(Surah 30.36)

Mischief has appeared
On land and sea because
Of (the meed) that the hands
Of men have earned,
That (God) may give them
A taste of some of their
Deeds: in order that they
May turn back (from evil).

(Surah 30.41)

But in whatever form the tribulation or punishment takes, whether in the form of a disease or of a material or personal loss, the person should not become desperate. Instead, the person should rely on the mercy of God and grow from the situation:

On no soul doth God
Place a burden greater
Than it can bear.
It gets every good that it earns,

And it suffers every ill that it earns.

(Surah 2.286)

...Nor kill (or destroy)
Yourselves: for verily
God hath been to you
Most Merciful!

(Surah 4.29)

Narrated by Abu Huraira: The Prophet said, "There is no disease that Allah has created, except that He also has created its treatment."

(Hadith Number 582, Volume 7, Book 71)

Another question concerning predestination deals with a more difficult theological question. This one involves the freedom of will an individual has in conducting his life and the sole responsibility that person has for his deeds. In other words, does predestination determine one's religious belief or lack of belief, and, therefore, is there a predestined fate for an individual to go to Paradise or to be condemned?

The Turkish mystic Yunus Emre (died 1321 A.D.) examined the responsibility of the human being in a poem:

O God, if You should question me, this would be my answer to it: I treated myself cruelly; I sinned. What did I do to You, O King? Before I came, You said my right share was bad; before I was even born, You said, "Adam

is very rebellious." If You have written me down as "rebellious from eternity," You will fill the world with the resulting clamor of my behavior. Was it I who fashioned me? No, it was You who fashioned me. Why did You create me filled with faults, O One Without Needs! I opened my eyes and the inside of the prison I saw was filled with the carnal self and desires and filled with devils. Let me not die in prison; open up! A number of times I have eaten some pure things as well as some unclean things. What decreased from Your realm? Your slaves make a bridge for good purposes. The good is so that they may pass over or for an excursion. It is necessary even that its foundation be firm, so that those passing over will say, "This is the Straight Path." You set up a scale to weigh my whims and desires; You intend to throw me into the fire. A scale is necessary for him who is a grocer or else a merchant, a trader, or a druggist. Since sin is the most unclean thing of unclean things, it is a matter not befitting Your majesty. You ought to conceal it with kindness. So, what need is there for You to reveal the uncleanness and weigh it? You will merrily watch as I burn. Heaven forbid that should happen, O God of Mankind. You are all-seeing; You indeed know my state; so what need have You to weigh my deeds? After having killed me, making me rot, filling my eye with dirt, hasn't Your need for taking revenge passed? No harm came to You from Yunus. You know that which is evident and that which is hidden. So many dry words for a mere handful of earth. Why is that neces-

sary, O kind and glorious God?

The Poetry of Yunus Emre, A Turkish Sufi Poet
by Grace Martin Smith, pages 127–128

On the one hand, the absolute will of God is emphasized as the sole reason for any happening, as for example in Surah 57.22, quoted at the beginning of the chapter. A variety of other verses can be found to support this interpretation:

> *He said, "Worship ye*
> *That which ye have*
> *(Yourselves) carved?*
> *But God has created you*
> *And your handiwork!"*

(Surah 37.95–96)

> *. . . Such is*
> *The guidance of God.*
> *He guides therewith*
> *Whom He pleases . . .*

(Surah 39.23)

> *This is an admonition:*
> *Whosoever will, let him*
> *Take a (straight) Path*
> *To his Lord.*
> *But ye will not*
> *Except as God wills;*
> *For God is full of*
> *Knowledge and Wisdom.*

(Surah 76.29–30)

Islamic mystics believe a person has no choice regarding his belief or lack of belief. Thus, the mystic Kalabadi (died circa 990 A.D.) said:

Someone who desires (murid) is in reality someone to be desired (murad), and someone to be desired is someone desiring; for whoever desires God only desires so through a desiring that emerges from God and a desiring that is obliging. God spoke:

He will love them as they will love Him . . .

(Surah 5.54)

That He wants them is thus reason for the fact that they want Him; as for everything, His doing is the reason without having any reason for His doing. When God wants a human being, the latter cannot want Him. The wanting became the wanted and the wanted, to the wanting.

(*Islamic Mysticism, Gramlich,* page 67)

On the other hand, some verses of the Koran indicate the freedom of decision-making and point to the responsibility of each human being for all his deeds, for his belief, or for his lack of belief:

Say, "The Truth is
From your Lord."
Let him who will,
Believe, and let him
Who will, reject (it).
(Surah 18.29)

If God so willed, He
Could make you all one People,
But He leaves straying
Whom He pleases, and He guides
Whom He pleases: but ye
Shall certainly be called to account
For all your actions.

(Surah 16.93)

In the Koran, the nonbeliever is represented as having a disease of the heart as a result of spiritual impenitence and arrogance:

As to those who reject Faith,
It is the same to them
Whether thou warn them
Or do not warn them;
They will not believe.
God hath set a seal
On their hearts and on their hearing,
And on their eyes is a veil;
Great is the penalty they (incur).
Of the people there are some who say,
"We believe in God and the Last Day";
But they do not (really) believe.
Fain would they deceive
God and those who believe,
But they only deceive themselves,
And realize (it) not!
In their hearts is a disease;
And God has increased their disease:
And grievous is the penalty they (incur),

Because they are false (to themselves).
(Surah 2.6-10)

The sealing of the heart and the senses should not be understood as the reason for a lack of belief, but rather this is a consequence of the intentional, knowing, and willing rejection of faith.

To such as God rejects
From His guidance, there can be
No guide. He will
Leave them in their trespasses
Wandering in distraction.

(Surah 7.186)

The statements of the Koran concerning the question of an individual's freedom of will are not straightforward. If, however, the individual were indeed not free in his actions and decisions, any kind of revelation conveyed by the prophets in regard to the commandments would be senseless.

The human being would be a weak-willed automaton and, thus, would be released from responsibility for his deeds and decisions. In addition, one could not speak of God's retribution for human deeds if these deeds were not the initiative of the human being, but were solely the will of God. This contradicts the revelations of God.

Therefore, one must assume that strokes of fate are what is meant by the notion of predestination. Unexpected unfortunate occurances over which an individual has no control are part of this concept. However, so are unforeseen good actions or consequences in life. These include lucky coincidences, attaining a highly honored position in society due to fortune or family,

special personal skills or talents, and riches. Yet one must also realize that these privileges are accompanied by a great deal of responsibility, for even knowledge and just power can be misused. Thus, Solomon *(Suleiman)* was, for example, conscious of the particular responsibility that his extraordinary wisdom and power demanded:

> *So he smiled, amused*
> *At her speech; and he said,*
> *"O my Lord! so order me*
> *That I may be grateful*
> *For Thy favors, which Thou*
> *Hast bestowed on me and*
> *On my parents, and that*
> *I may work the righteousness*
> *That will please Thee;*
> *And admit me, by Thy Grace,*
> *To the ranks of Thy*
> *Righteous Servants."*

(Surah 27.19)

> *". . . This is*
> *By the Grace of my Lord!*
> *To test me whether I am*
> *Grateful or ungrateful!*
> *And if any is grateful,*
> *Truly his gratitude is (a gain)*
> *For his own soul; but if*
> *Any is ungrateful, truly*
> *My Lord is free of all needs,*
> *Supreme in Honour!"*

(Surah 27.40)

Angels

The invisible world of angels is called Malakut. Angels are invisible and bodiless creatures made out of light. Unlike human beings, they do not possess any kind of emotion, and they do not have any independent will; they are incorruptible and free from sin. They follow God's orders without question. As a result, the concept of a fallen angel is unknown to Islam.

Man's God-given free will differentiates him from all other creatures. Thus, the angels threw themselves at Adam's feet because, as the first human being, he was also the first prophet.

Angels are entrusted with different kinds of tasks. On the one hand, God delivers his revelations through them:

He doth send down His angels
With inspiration of His command,
To such of His servants
As He pleaseth, (saying),
"Warn (Man) that there is
No god but I, so do
Your duty unto Me."

(Surah 16.2)

The angel Gabriel has special significance in delivering divine messages. For example, Muhammad received the content of the Koran through Gabriel:

Verily this is a Revelation
From the Lord of the Worlds.
With it came down
The Spirit of Faith and Truth

111

To thy heart and mind,
That thou mayest admonish . . .

(Surah 26.192–194)

In Islam, the "Holy Spirit" is understood as an epithet for the angel Gabriel. The birth of Jesus (Isa) was announced to Mary (Mariam) by the angels:

Behold! the angels said,
"O Mary! God hath chosen thee
And purified thee, chosen thee
Above the women of all nations."

(Surah 3.42)

Behold! the angels said,
"O Mary! God giveth thee
Glad tidings of a Word
From Him: his name
Will be Christ Jesus,
The son of Mary, held in honor
In this world and the Hereafter
And of (the company of) those
Nearest to God;
He shall speak to the people
In childhood and in maturity.
And he shall be (of the company)
Of the righteous."
She said, "O my Lord!
How shall I have a son
When no man hath touched me?"
He said: "Even so,
God createth

112

What He willeth,
When He hath decreed
A plan, He but saith
To it, 'Be,' and it is!
And God will teach him
The Book and Wisdom
The Law and the Gospel, . . ."

(Surah, 3.45–48)

Finally, it was the angel Gabriel who announced the birth of Jesus to Mary and, with God's permission, breathed into her the Spirit.

The details of the original procedure regarding the delivery of the divine revelation remain hidden as a miracle. Since these events cannot be explained in terms of daily human experience, humans are not capable of grasping this happening rationally:

They ask thee concerning
The Spirit (of inspiration).
Say, "The Spirit (cometh)
By command of my Lord.
Of knowledge it is only
A little that is communicated
To you . . ."

(Surah 17.85)

As for the rest, an angel breathes the soul into each and every human being, as explained in the following Hadith:

Narrated by 'Abdullah bin Mus'ud: Allah's Apostle, the true and truly inspired said, "The human being is put together in the mother's womb in forty days, and then he becomes a clot of thick blood for a similar period, and then a piece of flesh for a similar period. Then Allah sends an angel who is ordered to write four things. He is ordered to write down his deeds, his livelihood, the date of his death, and whether he will be blessed or wretched in religion. Then the soul is breathed into him. . ."

(Hadith Number 430, Volume 4, Book 54)

Furthermore, angels help human beings on behalf of God. They also aid humans by writing down deeds, the good as well as the bad ones:

But verily over you
(Are appointed angels)
To protect you,
Kind and honorable,
Writing down (your deeds),
They know (and understand)
All that ye do.

(Surah 82.10-12)

Behold, two (guardian angels)
Appointed to learn (his doings)
Learn (and note them),
One sitting on the right
And one on the left.
Not a word does he

> *Utter but there is*
> *A sentinel by him,*
> *Ready (to note it).*

<div align="right">(Surah 50.17–18)</div>

Finally, the Angel of Death ('Azra'il) receives the soul of the dying human being in order to return it to God:

> *Say, "The Angel of Death,*
> *Put in charge of you,*
> *Will (duly) take your souls,*
> *Then shall ye be brought*
> *Back to your Lord."*

<div align="right">(Surah 32.11)</div>

We learn from the Koran that the soul may leave the body in cases that do not involve the death of the body:

> *It is He Who doth take*
> *Your souls by night,*
> *And hath knowledge of all*
> *That ye have done by day.*
> *By day doth He raise*
> *You up again, that a term*
> *Appointed be fulfilled;*
> *In the end unto Him*
> *Will be your return;*
> *Then will He show you*
> *The truth of all*
> *That ye did.*
> *He is the Irresistible, (watching)*
> *From above over His worshippers,*

And He sets guardians
Over you. At length,
When death approaches
One of you, Our angels
Take his soul, and they
Never fail in their duty.

(Surah 6.60–61)

It is God that takes
The souls (of men) at death;
And those that die not
(He takes) during their sleep.
Those on whom He
Has passed the decree
Of death, He keeps back
(From returning to life),
But the rest He sends
(To their bodies)
For a term appointed.
Verily in this are Signs
For those who reflect.

(Surah 39.42)

In that respect, the famous saying that "sleep is the little brother of death" has a strong and vivid central reality in Islam.

From a theological point of view, the concept of the angels Munkar (Condemnable) and Nakir (Dreadful) questioning the deceased in the grave is more debatable. However, the pious still maintain a strong belief in this concept.

According to tradition, these two angels appear after the

funeral in order to ask the deceased about his faith and his life within his faith. No documentary evidence can be found in the Koran regarding the questioning inside the grave; however, it is referred to within the content of some Hadiths:

> Narrated by Abu Huraira: Allah's Apostle used to invoke Allah, "Allahumma ini a'udhu bika min 'adhabi-l-Qabr, wa min 'adhabi-nnar, wa min fitnati-l-mahya wa-lmamat, wa min fitnati-l-masih ad-dajjal" (O Allah! I seek refuge with you from the punishment in the grave and from the punishment in the hell fire and from the afflictions of life and death, and the afflictions of Al-Masih Ad-Dajjal).
>
> (Hadith Number 459, Volume 2, Book 23)

> Narrated by Anas: The Prophet said, "When a human being is laid in his grave and his companions return and he even hears their footsteps, two angels come to him and make him sit and ask him: 'What did you use to say about this man, Muhammad?' He will say: 'I testify that he is Allah's slave and His Apostle.' Then it will be said to him, 'Look at your place in the hell fire. Allah has given you a place in Paradise instead of it.'" The Prophet added, "The dead person will see both his places. But a nonbeliever or a hypocrite will say to the angels, 'I do not know, but I used to say what the people used to say!' It will be said to him, 'Neither did you know nor did you take the guidance (by reciting the Qur-an).' Then he will be hit with an iron hammer between his two ears, and he will cry and that cry, will

be heard by whatever approaches him except human beings and jinn."

(Hadith Number 422, Volume 2, Book 23)

This Hadith certainly causes skepticism in that it is described in such detail. We need to be clear about the fact that this is a "healthy" Hadith, meaning that it has a strong traditional chain. The problem with the interpretation of Hadiths is that many of them, particularly the ones regarding the Day of Judgment , contain descriptions in such great detail that they should not be understood literally but rather metaphorically. Such picturesque and vivid comparisons are used to help the imagination understand the concept. A literal interpretation of the Hadiths and the Koran is inappropriate in Islamic theology when such an interpretation contradicts experience and reason.

Thus, this Hadith is not supposed to be understood literally but symbolically. In this case, several reasons arise for a metaphorical interpretation. On the one hand, a Christian or a Jew would most likely not know how to handle a question about what he had said about Muhammad during his lifetime, and this lack of a satisfactory answer would probably lead to his doom. However, each human being will be rated and judged on the Day of Judgment according to the intent of his deeds and according to the demands of his own denomination. The Koran makes this clear:

And there are, certainly,
Among the People of the Book,
Those who believe in God,
In the revelation to you,
And in the revelation to them,

Bowing in humility to God:
They will not sell
The Signs of God
For a miserable gain!
For them is a reward
With their Lord,
And God is swift in account.

(Surah 3.199)

On the other hand, God's mercy does not permit humans to know everything. This includes the mysteries of the human soul, particularly what happens to the soul after death and on the Day of Judgment. Such knowledge about the terror that is to come on Day of Judgment would be too great a burden for the fragile human psyche:

Do they see nothing
In the government of the heavens
And the earth and all
That God hath created?
(Do they not see) that
It may well be that
Their term is nigh
Drawing to an end?
In what Message after this
Will they then believe?

(Surah 7.185)

An exclamation of the Prophet reads: "O followers of Muhammad! By Allah! If you knew that which I know, you would laugh little and weep much."

(Hadith, Number 154, Volume 2, Book 18)

The tradition of the questioning inside the grave means that after death, a person has to justify what he has done during his lifetime. In addition, he has to announce his personal divinity or even idol. In today's world, riches, social position, and power are just as much idols to be worshipped as people and statues.

The question of what might have been said about Muhammad during his lifetime must be considered exchangeable. Thus, a Christian could be questioned about what he said about Jesus, and a Jewish person might be asked what he said about Moses or David. We are dealing with the relation of the individual to his religion. In other words, during his lifetime, did he observe what his religion demanded?

For this interpretation, two significant Koran verses and two Hadiths show us the interrogation inside the grave:

> . . . To each among you
> Have We prescribed a Law
> And an Open Way.
> If God had so willed,
> He would have made you
> A single People, but (His
> Plan is) to test you in what
> He hath given you. So strive
> As in a race in all virtues.
> The goal of you all is to God;
> It is He that will show you
> The truth of the matters
> In which ye dispute;

(Surah 5.48)

To every People have We
Appointed rites and ceremonies
Which they must follow . . .

(Surah 22.67)

Narrated by Al-Bara' bin 'Azib: The Prophet said, "When a faithful believer is made to sit in his grave, then (the angels) come to him and he testifies that none has the right to be worshipped but Allah, and Muhammad is Allah's Apostle. And that corresponds to Allah's statement: 'Allah will keep firm those who believe with the word that stands firm.'"

(Hadith Number 450, Volume 2, Book 23)

Narrated by Abu 'Amr from Uthman Ibn 'Affan: "After the burial of a dead man, Allah's Messenger would stay by the grave and say 'Seek forgiveness for your brother and supplicate for him for steadfastness because he is being questioned (about his deeds) now."

(Hadith Number 946, Volume II)

For Muslims, the tradition of interrogation inside the grave is important because it is an essential part of the funeral rite. During the funeral procession, the mourners try to prepare the deceased for the interrogation by the angels. Here is one formula:

"O servant of God! Remember the duty that you have accepted before leaving this earth. The knowledge that there is no other divinity beside the one single God, and that Muhammad is the messenger of this one single God; that the belief in Paradise repre-

sents the truth and that hell is truth and that the inter-
rogation inside the grave is the truth, and that there is
no doubt about the fact that the Day of Judgment is
to come, that day on which God will awaken those
inside the graves, and you will realize that God is your
Lord."

The belief in the interrogation inside the grave is not neces-
sary, for even to doubt a strong Hadith does not mean Kufr
(refusal of faith, that is to say, nonbelief). However, one must
believe in the Day of Judgment on which deeds will be judged.

Other angels act as guardians. According to a Hadith, the city
of Medina is protected from the false prophet, that is to say, the
false Messiah (Dajjal) by angels:

> Narrated by Abu Huraira: Allah's Apostle said, "There
> are angels guarding the entrances (or roads) of
> Medina, neither plague nor Ad-Dajjal will be able to
> enter it."

(Hadith Number 104, Volume 3, Book 30)

An angel announces the Day of Judgment by thrusting a
trumpet or horn into the Sur. By tradition, the angel the Israfil
announces the doomsday by blowing this instrument.
Considering the significance of the event, the instrument can
only symbolically be compared with a trumpet or a horn.

The Trumpet will (just)
Be sounded, when all
That are in the heavens
And on earth will swoon,

Except such as it will
Please God (to exempt).
Then will a second one
Be sounded, when, behold,
They will be standing
And looking on!
And the earth will shine
With the glory of its Lord;
The Record (of Deeds)
Will be placed (open);
The prophets and the witnesses
Will be brought forward;
And a just decision
Pronounced between them;
And they will not
Be wronged (in the least).

(Surah 39.68–69)

And listen for the day
When the Caller will call
Out from a place
Quite near,
The Day when they will
Hear a (mighty) blast
In (very) truth; that
Will be the Day
Of Resurrection.

(Surah 50.41–42)

According to the Koran, the angel Malik, among others, is responsible for the fire of hell:

The sinners will be
In the punishment of hell,
To dwell therein (for aye).
Nowise will the (punishment)
Be lightened for them,
And in despair will they
Be there overwhelmed.
Nowise shall We
Be unjust to them.
But it is they who
Have been unjust themselves.
They will cry, "O Malik!
Would that thy Lord
Put an end to us!"
He will say, "Nay, but
Ye shall abide!"

(Surah 43.74-77)

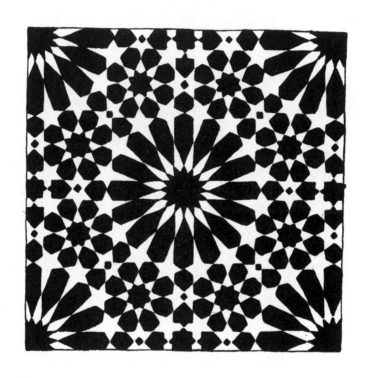

A tile motif from the Alhambra in Granada, Spain.

The Jinn

We created man from sounding clay,
From mud moulded into shape;
And the jinn race, We had
Created before, from the fire
Of a scorching wind.

(Surah 15.26–27)

And He created jinns
From fire free of smoke.

(Surah 55.15)

One day will He gather
Them all together, (and say),
"O ye assembly of jinns!
Much (toll) did ye take
Of men." Their friends
Amongst men will say,
"Our Lord! we made profit
From each other, but (alas!)
We reached our term
Which Thou didst appoint
For us." He will say,
"The fire be your dwelling-place.
You will dwell therein forever,
Except as God willeth."
For thy Lord is full
Of wisdom and knowledge.

(Surah 6.128)

"O ye assembly of jinns
And men! came there not
Unto you apostles from amongst you,
Setting forth unto you
My Signs, and warning you
Of the meeting of this Day
Of yours?" They will say,
"We bear witness against
Ourselves." It was
The life of this world
That deceived them. So
Against themselves will they
Bear witness that they
Rejected Faith.

(Surah 6.130)

Many are the jinns and men
We have made for hell:
They have hearts wherewith they
Understand not, eyes wherewith
They see not, and ears wherewith
They hear not. They are
Like cattle, nay more
Misguided, for they
Are heedless (of warning).

(Surah 7.179)

The jinn are creatures that exist on a more refined plane than human beings. From the Koran verse at the beginning of this section, we can infer that the jinn were created before Man. God created Man from clay (Surah 55.14), but God created the jinn from fire, not from bodily or material elements. Unlike angels,

the jinn have the same free will that humans have. We know this because the jinn are able to refuse faith. The word "jinn" comes from the root word "janna," meaning "to be hidden" or "to hide or conceal."

The term "jinn" also refers to creatures that belong to the realm of spirits. This does not include the wild beings from the fairy tales found in *One Thousand and One Arabian Nights*. In fact, psychological forces can also be used to explain the ideas behind the jinn. On the other hand, the jinn are not the spirits of the deceased; they are a life form that is independent from that of human existence, and they cannot be understood.

Detailed descriptions of the jinn and of demons found in Muslim literature have been based on pure conjecture. We know this because the statements of the Koran and of the Hadiths are not always to be understood literally. The existence of other more highly refined life forms, such as the jinn and angels, cannot be proven conclusively and, thus, remain a mystery. The jinn are normally invisible to human beings, but they can cause visible deeds or even audible noises. On occasion, the jinn are provoked into action through séances and other occult practices. We will expand on this in the following chapter about Satan and the demons.

In addition to their other abilities, the jinn are able to imitate people. This is what happens when we try to establish contact with a deceased loved one in a séance. According to Islamic interpretation, the reactions are not the answers of the deceased because their souls have already been led to God. Instead, they are those of a jinn which, based on its powers of observation, is also capable of knowing personal habits and living conditions of the deceased. Therefore, test questions regarding the favorite

drink of the deceased have no real relevance as evidence. The answers are only the deceptive actions of these creatures. In addition, these spiritual sessions can be harmful for the psyche of the human being. Because séances are considered senseless, deceptive, and even dangerous experiments in communicating with a creature that no longer resides on the plane of human existence, they are prohibited in Islam (*haram*).

However, the jinn are still regarded as creatures of God. Like Man, they are mortal and will be judged on the Last Day. However, the Koran does not include any mention of gender in relation to the jinn. Therefore, one should not try to humanize these creatures.

The Koran repeats the idea that God created everything in pairs. However, this does not always refer to any kind of sexuality. It can also mean opposition or pairs such as positive and negative. Thoughts and psychological forces that belong to the jinn appear in pairs as well; for instance, positive is creative, and negative is destructive. Other examples include day and night, positive and negative electrical charges, sweet water and salty ocean water.

Say, It has been
Revealed to me that
A company of jinns
Listened (to the Qur-an).
They said, "We have
Really heard a wonderful recital.
It gives guidance
To the Righteous,
And we have believed therein.
We shall not join (in worship)
Any (gods) with our Lord.

And exalted is the Majesty
Of our Lord. He has
Taken neither a wife
Nor a son.
There were some foolish ones
Among us, who used
To utter extravagant lies
Against God;
But we do think
That no man or spirit
Should say aught that is
Untrue against God.
True, there were persons
Among mankind who took shelter
With persons among the jinns,
But they increased them
In folly.
And they (came to) think
As ye thought, that God
Would not raise up
Anyone (to Judgment).
And we pried into
The secrets of heaven;
But we found it filled
With stern guards
And flaming fires.
We used, indeed, to sit there
In (hidden) stations, to (steal)
A hearing; but any
Who listens now
Will find a flaming fire
Watching him in ambush.

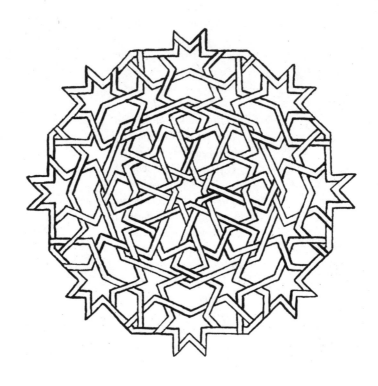

A tile motif from the Alhambra in Granada, Spain.

And we understand not
Whether ill is intended
To those on earth,
Or whether their Lord
(Really) intends to guide
Them to right conduct.
They are among us
Some that are righteous,
And some the contrary.
We follow divergent paths.
But we think that we
Can by no means frustrate
God throughout the earth,
Nor can we frustrate Him
By flight.
And as for us,
Since we have listened
To the Guidance, we have
Accepted it, and any
Who believes in his Lord
Has no fear, either
Of a short (account)
Or of any injustice.
Amongst us are some
That submit their wills
(To God), and some
That swerve from justice.
Now those who submit
Their wills they have
Sought out (the path)
Of right conduct."

(Surah 72.1–14)

The Koran indicates that in addition to Man and the jinn, the devils or demons also had to follow God's orders. He was able to make their abilities subservient to his will:

> *To Solomon We inspired*
> *The (right) understanding*
> *Of the matter; to each*
> *(Of them) We gave Judgment*
> *And Knowledge; it was*
> *Our power that made*
> *The hills and the birds*
> *Celebrate Our praises,*
> *With David. It was We*
> *Who did (all these things).*
> *It was We Who taught him*
> *The making of coats of mail*
> *For your benefit, to guard*
> *You from each other's violence.*
> *Will ye then be grateful?*
> *(It was Our power that*
> *Made) the violent (unruly)*
> *Wind flow (tamely) for Solomon,*
> *To his order, to land*
> *Which We had blessed:*
> *For We do know all things.*
> *And of the evil ones,*
> *Were some who dived*
> *For him, and did other work*
> *Besides; and it was We*
> *Who guarded them.*

Surah 21.79–82)

And Solomon was David's heir.
He said, "O ye people!
We have been taught the speech
Of birds, and on us
Has been bestowed (a little)
Of all things. This is
Indeed Grace manifest (from God)."
And before Solomon were marshaled
His hosts, of jinns and men
And birds, and they were all
Kept in order and ranks.

(Surah 27.16–17)

And to Solomon (We
Made) the Wind (obedient).
Its early morning (stride)
Was a month's (journey),
And its evening (stride)
Was a month's (journey).
And We made a Font
Of molten brass to flow
For him, and there were
jinns that worked in front
Of him, by the leave
Of his Lord, and if any
Of them turned aside
From Our command, We
Made him taste
Of the penalty
Of the blazing fire.

They worked for him
As he desired, (making) arches,
Images, basons
As large as Reservoirs,
(And cooking) cauldrons fixed
(In their places). "Work ye,
Sons of David, with thanks!
But few of My servants
Are grateful!"

(Surah 34.12–13)

The jinn have the capability to observe Man secretly and to provoke all kinds of hallucinations. Nevertheless, one should not assume that the jinn are able to predict future events. Thus, like all other living beings, the jinn did not notice at first that Solomon had been dead for a long time. Only when the rod on which Solomon used to lean became fragile and broke apart and the lifeless body of the king collapsed, did they finally notice that Solomon was dead:

Then, when We decreed
(Solomon's) death, nothing showed them
His death except a little
Worm of the earth, which
Kept (slowly) gnawing away
At his staff. So when he
Fell down, the jinns saw
Plainly that if they had
Known the unseen, they

Would not have tarried
In the humiliating penalty
(Of their task).

(Surah 34.14)

After Solomon's death, no other human being had power over the jinn and the demons.

Satan and the Demons

According to Islamic interpretation, Satan (Iblis or Shaytan) is not a fallen angel since angels do not have a proper will. Rather, Satan is a fallen jinn, a jinn who has refused to obey the will of God. The word "Shaytan" is derived from the verb "shatana," which means "he was far away." This is interpreted to mean he is far away from all that is good and truthful. Another root for Shaytan is the word "shata," meaning "hot."

In Surah 72.4, the jinn call Iblis a "jester" or "fool." The name "Iblis" means "the disappointed." The following verse explains why Satan is disappointed and refuses to obey God:

> Behold! We said
> To the angels, "Bow down
> To Adam." They bowed down
> Except Iblis. He was
> One of the jinns, and he
> Broke the Command
> Of his Lord.
> Will ye then take him
> And his progeny as protectors
> Rather than Me? And they
> Are enemies to you!
> Evil would be the exchange
> For the wrongdoers!

> (Surah 18.50)

Behold, thy Lord said
To the angels. "I am
About to create Man
From clay:
When I have fashioned him
In (due proportion) and breathed
Into him of My spirit,
Fall ye down in obeisance
Unto him."
So the angels prostrated themselves,
All of them together;
Not so Iblis: he
Was haughty, and became
One of those who reject Faith.
(God) said, "O Iblis!
What prevents thee from
Prostrating thyself to one
Whom I have created
With My hands?
Art thou haughty?
Or art thou one
Of the high (and mighty) ones?"
(Iblis) said: "I am better
Than he: Thou created
Me from fire, and him
Thou created from clay."
(God) said: "Then get thee
Out from here: for thou
Art rejected, accursed.
And My curse shall be
On thee till the Day
Of Judgment."

(Iblis) said: "O my Lord!
Give me then respite
Till the Day
The (dead) are raised."
(God) said: "Respite then
Is granted thee
Till the Day
Of the time appointed."
(Iblis) said: "Then,
By Thy Power, I will
Put them all in the wrong,
Except Thy servants
Amongst them, sincere
And purified (by Thy grace)."
(God) said: "Then
It is just and fitting,
And I say what is
Just and fitting
That I will certainly fill
Hell with thee
And those that follow thee,
Every one."

(Surah 38.71–85)

From the text, it seems Iblis was not the only one who refused to throw himself at Adam's feet. Other disobedient jinn did so as well. Most likely, Iblis is mentioned in particular because he led the revolt. The jinn that joined Iblis are called satans, devils, or demons.

According to the Koran, each human being is accompanied by angels and by a Shaitan (a demon) that tempts him to do evil. When the human dies, the demon also dies.

141

And the stupor of death
Will bring truth (before
His eyes): "This was
The thing which thou
Wast trying to escape!"
And the trumpet
Shall be blown:
That will be the Day Whereof
Warning (had been given).
And there will come forth
Every soul: with each
Will be an (angel) to drive,
And an (angel) to
Bear witness.
(It will be said:)
"Thou wast heedless
Of this; now have We
Removed thy veil,
And sharp is thy sight
This Day!"
And his Companion will say:
"Here is (his record) ready
With me!"
(The sentence will be:)
"Throw, throw into hell
Every contumacious rejecter
(Of God)!
Who forbade what was good,
Transgressed all bounds,
Cast doubts and suspicions;
Who set up another god
Beside God; throw him

142

Into a severe penalty."
His Companion will say:
"Our Lord! I did not
Make him transgress,
But he was (himself)
Far astray."
He will say: "Dispute not
With each other
In my Presence:
I had already in advance
Sent you warning."

(Surah 50.19-28)

Satan (Iblis) is not any kind of abstract force of evil but a creature with a personality, just like a human being. The difference between him and the other jinn is that he will die within the fixed period of time that was granted to him, though this does not take place until the Last Judgment. His disobedience is caused by haughtiness and vanity. He considered himself better than the physical creation of Man. His disappointment is based on jealousy. Iblis felt rejected by God, who honored Man above all other creatures. Man is the lord of the earth, and it was for him that everything had been created. He is considered the most valuable and most important creature and plays the leading role on earth. He has the power but, it should be remembered, also the responsibility.

Behold, thy Lord said to the angels: "I will create
A vice-regent on earth."
...And He taught Adam the nature
Of all things;..."

(Surah 2.30-31)

"It is He who hath created for you
All things that are on earth . . ."

(Surah 2.29)

The Islamic mystic Al-Hallaj (executed in 309 A.D.) assumed that Iblis was a despised lover. Satan refused to throw himself at Adam's feet because he only wanted to throw himself before God, the sole one worthy of worship. Accordingly, Satan considered throwing himself before a material body a betrayal of God's love. Even though Al-Hallaj's interpretation is logical, he could not base his suppositions about Satan's motive on the Koran. His refusal is not quite so noble in the Koran as one could assume by reading the descriptions of Al-Hallaj. In several places, the Koran states that Satan considered himself the better creation, although God had only breathed into the human being.

In addition, the statement "I am better than he," criticizes God's creation of Adam as being faulty compared to his own creation. This is the haughtiness we mentioned: pride in regard to Man and toward God. If Iblis had truly and honestly loved, respecting the will and the sovereignty of God, he would have accepted the creation of Man. However, Iblis did not reach beyond jealous love, which in reality is only projected narcissism.

He said, "Seest Thou? This is
The one whom Thou hast honoured
Above me! . . ."

(Surah 17.62)

God taught Adam all names, the knowledge of which distinguishes him from all other creatures. According to Islamic theology, when we speak of "names," we mean the inner being and the characteristics of things. These "things" include sensations and feelings. Thus, Adam deserved the honor of all other creatures bowing to him as a symbol of the highest creation among all the creatures formed by God.

Because Iblis is hostile towards human beings, he tries to distract them from God and to lead them into temptation. In this way, he wants to provoke God. By exploiting Man's weaknesses, he wants to prove to God that Man is not worthy of being God's vice-regent on earth and does not deserve the highest form of honor and respect from all other beings:

He said, "Because thou
Hast thrown me out
Of the Way, lo! I will
Lie in wait for them
on Thy Straight Way:
Then will I assault them
From before them and behind them,
From their right and their left;
Nor wilt Thou find,
In most of them,
Gratitude (for Thy mercies)."

(Surah 7.16–17)

"I will mislead them,
And I will create
In them false desires; I will
Order them to slit the ears

Of cattle, and to deface
The (fair) nature created
By God." Whoever,
Forsaking God, takes Satan
For a friend, hath
Of a surety suffered
A loss that is manifest.
Satan makes them promises,
And creates in them false desires;
But Satan's promises
Are nothing but deception.

(Surah 4.119–120)

"Lead to destruction those
Whom thou canst among them,
With thy (seductive) voice;
Make assaults on them
With thy cavalry and thy
Infantry; mutually share
With them wealth and children;
And make promises to them."
But Satan promises them
Nothing but deceit.

(Surah 17.64)

The first confrontation between Man and Satan occurred when he convinced Adam and Eve (Hawwa) to approach the forbidden tree:

Then We said, "O Adam!
Verily, this is an enemy
To thee and thy wife,
So let him not get you

Both out of the Garden,
So that thou art landed
In misery.
There is therein (enough provision)
For thee not to go hungry
Nor to go naked,
Nor to suffer from thirst,
Nor from the sun's heat."
But Satan whispered evil
To him. He said, "O Adam!
Shall I lead thee to
The Tree of Eternity
And to a kingdom
That never decays?"
In the result, they both
Ate of the tree, and so
Their nakedness appeared
To them. They began to sew
Together, for their covering,
Leaves from the Garden.
Thus did Adam disobey
His Lord, and allow himself
To be seduced.

(Surah 20.117-121; *see also* 2.35-36)

So by deceit he brought about
Their fall . . .

(Surah 7.22)

In Islamic theology, The Fall doesn't deal with The Tree of Knowledge. In fact, Man actually had much deeper knowledge then than he does now because God had taught him all names.

It is commonly assumed that The Fall involved the Tree of Evil. Adam was forbidden to eat from this tree and should not even have been near it. In Surah 17.60, we see a reference to the "Cursed Tree." The tree itself represents anything that is forbidden. It was a test to help increase Man's will and to examine Man's faithfulness to God.

We should note that unlike the Old Testament, the version in the Koran does not hold Eve responsible for Adam's mistake. According to the Koran, Satan seduces both Adam and Eve into eating the fruit from the tree.

In a different verse of the Koran, we find other words with which Satan convinced Adam and Eve:

> *Then began Satan to whisper*
> *Suggestions to them, bringing*
> *Openly before their minds*
> *All their shame*
> *That was hidden from them*
> *(Before). He said, "Your Lord*
> *Only forbade you this tree,*
> *Lest ye should become angels*
> *Or such beings as live forever."*

(Surah 7.20)

The error that Adam and Eve had committed was forgetting that Man already had privilege and position over all other creatures, including the angels. Man forgot his proper dignity as the vice-regent of God. In addition, Man believed he could be immortal and independent like God himself.

The human being is born pure, innocent, and free of all evil.

The Koran says that evil (malicious, negative thoughts, hatred, haughtiness, envy, jealousy, greed, etc.) is the result of the insinuations and workings of Satan. In other words, evil comes from the outside and is not part of human creation. Satan and the Sufi embody the essence of the negative. Satan lies in wait for the human being in order to seduce him and to lead him astray from the right path. This is also a symbolic representation of the human psyche when negative and destructive thoughts sneak in almost unnoticed. Every human being experiences this. Therefore, Surah 114, a Surah of protection, is often recited during prayer:

> *Say, I seek refuge*
> *With the Lord*
> *And Cherisher of Mankind,*
> *The King (or Ruler)*
> *Of Mankind,*
> *From the mischief*
> *Of the Whisperer*
> *(Of Evil), who withdraws*
> *(After his whisper),*
> *(The same) who whispers*
> *Into the hearts of Mankind,*
> *Among jinns*
> *And among Men.*

(Surah 114)

However, Satan only has power over those human beings that let themselves be seduced; he has no control over humans:

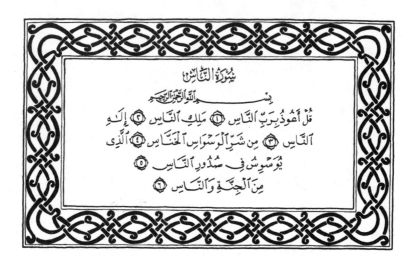

Surah 114 (Surah-t-an-Nas, a Surah of protection).

And Satan will say
When the matter is decided,
"It was God Who gave you
A promise of Truth. I, too,
Promised, but I failed
In my promise to you.
I had no authority over you
Except to call you, but ye
Listened to me. Then
Reproach not me, but reproach
Your own souls. I cannot listen
To your cries, nor can ye
Listen to mine. I reject
Your former act in associating
Me with God.
For wrongdoers there must be
A grievous penalty."

(Surah 14.22)

When Adam and Eve ate from the forbidden tree, it became clear to them that Satan had deceived them both. They also became conscious of the fact that they had lost their innocence through this disobedience. They felt ashamed and exposed. All their bad characteristics were revealed. They tried to balance this by covering their physical being with leaves. Adam and Eve truly regretted their mistake and asked God for forgiveness:

They said, "Our Lord!
We have wronged our own souls.
If Thou forgive us not
And bestow not upon us

151

> Thy Mercy, we shall
> Certainly be lost."

(Surah 7.23)

> They learnt Adam from his Lord
> Words of inspiration, and his Lord
> Turned towards him; for He
> Is Oft-Returning, Most Merciful.

(Surah 2.37)

> But his Lord chose him
> (For His Grace). He turned
> To him, and gave him guidance.

(Surah 20.122)

Because their repentance was sincere, God forgave them. In these verses, it is clear that guilt and repentance depend on the individual. Thus, the idea of inherited sin or Original Sin is unknown to Islam and, by extension, so is the idea of its atonement through the Crucifixion. Each living being is only responsible for his or her own actions. The regret for any misbehavior must be felt and carried out sincerely, and it must be accompanied by a resolution not to make the same mistake again. This is the "return" of the human being to God after which forgiveness is granted.

Each human being has the opportunity to prove himself during his earthly life.

> (God) said, "Get ye down,
> With enmity between yourselves.
> On earth will be your dwelling-place

And your means of livelihood,
For a time."
He said, "Therein shall ye
Live, and therein shall ye
Die; but from it shall ye
Be taken out (at last)."

(Surah 7.24-25; *see also* 20.123 and 2.38)

We said, "Get ye down all from here;
And if, as is sure, there comes to you
Guidance from Me, whosoever
Follows My guidance, on them
Shall be no fear, nor shall they grieve."

(Surah 2.38; *see also* 7.123)

Satan, the spirit of evil, and Adam and Eve left Paradise. This is the meaning of the phrase "all together." The sentence, "The one is the enemy of the other," indicates that Satan is the enemy of Man. This concept is repeated in other sections of the Koran.

Unlike the repentant Adam and Eve, whom God forgave, Satan was eternally cursed for his haughtiness and arrogance. Satan and his followers, the demons, are also called devils and stoned (rajm) devils because they have stones thrown at them from all sides. They are outcasts everywhere because they are opposed to the divine order. Vivid descriptions of how the demons are pursued are found in the following Surahs:

We have indeed decked
The lower heaven with beauty
(In) the stars,
(For beauty) and for guard

> *Against all obstinate*
> *Rebellious evil spirits,*
> *(So) they should not strain*
> *Their ears in the direction*
> *Of the Exalted Assembly*
> *But be cast away*
> *From every side,*
> *Repulsed, for they are*
> *Under a perpetual penalty,*
> *Except such as snatch away*
> *Something by stealth, and they*
> *Are pursued by a flaming*
> *Fire, of piercing brightness.*

(Surah 37.6–10)

> *It is We Who have set out*
> *The Zodiacal Signs in the heavens,*
> *And made them fair-seeming*
> *To (all) beholders;*
> *And (moreover) We have guarded them*
> *From every evil spirit accursed.*
> *But any that gains a hearing*
> *By stealth, is pursued*
> *By a flaming fire, bright (to see).*

(Surah 15.16–18; *see also* 26.212, 67.5, *and* 72.9)

The constellations serve as decorations and as aids to celestial orientation. For example, the sign of the zodiac marks the position of the sun in the course of one year as well as the moon and the other planets. The twelve parts of the zodiac characterize the position of the sun in the different months. This allows us to calculate the different seasons of a sun year and other meteoro-

logical factors. However, these astronomical dates do not allow one to draw any conclusions regarding future events, despite the claims of astrologers and their followers. These endeavors are basically superstition and are incompatible with monotheism.

One can assume that the term "piercing brightness" indicates that shooting stars, acting as projectiles, are meant to prevent the demons from rising into other spheres. With this interpretation, physical events are linked with spiritual observations for which modern science can give no suitable explanation.

The commentators explain the motives of the demons for listening to the conversations of the angels in various ways. According to Yusuf 'Ali, the demons want to participate in the beauty and harmony of the universe. However, because they deny the basic idea of the divine harmony and do not want to place themselves in the divine order, they are punished with the "piercing brightness." A symbolic meaning is thus given to light as it is used to fight the dark forces (demons).

According to Daryabadi, the demons try to listen to the angels' conversations to gain insight about future events which they then communicate to human beings who are preoccupied with the occult. This interpretation fits the statements in the Koran because the demons want to listen to the angels secretly. In Surah 37.8, the angels are referred to as "higher inhabitants." In addition, the Hadiths also support this interpretation:

> Narrated by Aisha: Some people asked Allah's Apostle about the foretellers. He said, "They are nothing." They said, "O Allah's Apostle! Sometimes they tell us of a thing which turns out to be true." Allah's Apostle said, "A jinn snatches that true word and pours it into

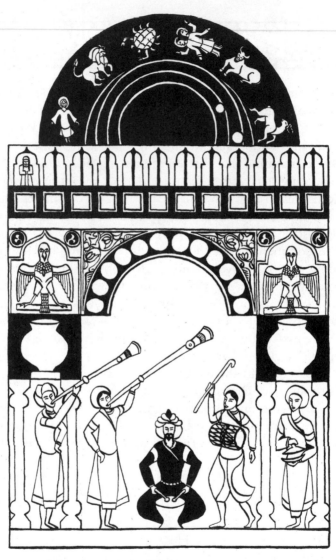

A miniature of the celestial clock of al-Jazari, a Turkish scientist (middle of the thirteenth century A.D.).

the ear of his friend (the foreteller) (as one puts something into a bottle). The foreteller then mixes with that word one hundred lies."

(Hadith Number 1,668, Volume II)

Any effort to predict the future, using astrology, Tarot cards, reading palms, séances, etc., is prohibited in Islam (haram):

Say: None in the heavens
Or on earth, except God
Knows what is hidden . . .

(Surah 27.65)

Forbidden to you (for food)
Are: dead meat, blood,
The flesh of swine, and that . . .
(Forbidden) also is the division
(Of meat) by raffling
With arrows; that is impiety.

(Surah 5.3)

Evil omens are equated to soothsaying:

"They said, "Your evil omens
Are with yourselves . . ."

(Surah 36.19)

Narrated by Qubisah Ibn al-Mukhariq: I heard Allah's Messenger saying, "The practice of Iyafah, the interpretation of omens from the flight of birds, the practice of divination by drawing lines on the ground and taking evil omens are all practices of al-Jibt (satanic deeds)."

(Hadith Number 1,679, Volume II)

Soothsaying in all its varieties is considered magic and is strictly forbidden in Islam, including white magic.

> " . . . But they could not thus
> Harm anyone except
> By God's permission.
> And they learned what harmed them,
> Not what profited them.
> And they knew that the buyers
> Of (magic) would have
> No share in the happiness
> Of the Hereafter. And vile
> Was the price for which
> They did sell their souls,
> If they but knew!"

(Surah 2.102)

The confidence in magic is considered Kufr (refusal of belief, unbelief) because magic denies the sovereignty of God's will. It is also considered Shirk (attaching oneself to something) because the soothsayer or magician would know things that are hidden and could influence future events. Splitting magic into white magic and black magic is a differentiation based on how humans

perceive magic. However, this distinction is meaningless because what might help one person under certain circumstances might be harmful to another person or to the same person at a different time. In addition, that which seems momentarily beneficial may actually prove to be a curse.

On many occasions, ranging from important undertakings to simply eating a meal or entering a house, Muslims say "Bismi'llahi'r-Rahmani 'r-Rahim" (In the name of God, the all forgiving, the most merciful). At the conclusion of the action, they add, "Al-hamdu li'llahi" (All praise is for Allah). These words reflect the hope that Satan has been excluded or expelled from the undertaking:

> Narrated by Jabir: I heard Allah's Messenger saying, "If a person mentions the Name of Allah upon entering his house or eating, Satan says, addressing his followers: 'You will find nowhere to spend the night and no dinner.' But if he enters without mentioning the Name of Allah, Satan says to his followers: 'You have found a place to spend the night.' And if he does not mention the Name of Allah at the time of eating, Satan says: 'You have found a place to spend the night as well as food.'"
>
> (Hadith Number 730, Volume I)

Another symbolic act to protect against Satan involves pronouncing the words "A'udhu bi'llahi mina'sh-shaytani'r-rajim" (I seek refuge in God from Satan, the rejected) and blowing over your left shoulder three times. According to the Sunnah, you should do this after you have a bad dream. Blowing

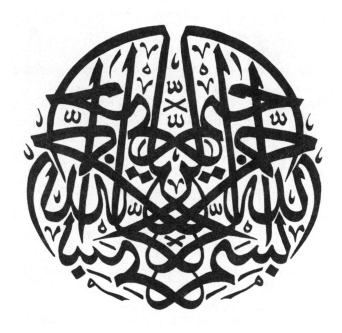

Calligraphy: "Bismi'llahi'r-Rahmani 'r-Rahim" (the glorification praise).

over your left shoulder three times symbolizes chasing Satan:

> Narrated by Abu Qatada: The Prophet said, "A good dream that comes true is from Allah, and a bad dream is from Satan, so if anyone of you sees a bad dream, he should seek refuge with Allah from Satan and should spit on the left, for the bad dream will not harm him."
>
> (Hadith 115, Volume 9, Book 87)

The preferred use of right limbs is found in Hadiths indicating that Satan feeds himself with his left hand:

> Narrated by Jabir: "I heard Allah's Messenger saying: 'Do not eat with your left hand, because Satan eats and drinks with his left hand.'"
>
> (Hadith 1,634, Volume II)

However, the left side does not always symbolize the satanic side:

> Narrated by 'Abdullah: "You should not give away a part of your prayer to Satan by thinking that it is necessary to depart (after finishing the prayer) from one's right side only; I have seen the Prophet often leave from the left side."
>
> (Hadith 811, Volume I, Book 12)

The preference for using right limbs is based on the hope that on the Day of Judgment those on the "right" path will have their deeds written with their right hand so that they may enter Paradise. "Right" signifies honesty or orthodoxy:

Calligraphy: "Al-hamdu li'llahi" (All Praise is for Allah).

One day We shall call
Together all human beings
With their (respective) Imams.
Those who are given their record
In their right hand
And they will not be
Dealt with unjustly
In the least.

(Surah 17.71)

Soon will his account
Be taken by an easy reckoning!
And he will turn
To his people, rejoicing!
But he who is given
His record behind his back,
Soon will he cry
For perdition,
And he will enter
A blazing fire.

(Surah 84.7–12)

But those who reject
Our Signs, they are
The (unhappy) companions
Of the left hand.

(Surah 90.19)

Judgment Day in Islam

Then contemplate (O man!)
The memorials of God's Mercy
How He gives life
To the earth after
Its death. Verily, the Same
Will give life to the men
Who are dead: for He
Has power over all things.

(Surah 30.50)

It is He Who brings out
The living from the dead,
And brings out the dead
From the living, and Who
Gives life to the earth
After it is dead:
And thus shall ye be
Brought out (from the dead).

(Surah 30.19)

In Islam, death is simply an intermediate stop. In addition to the death of an individual form of life, death also occurs on a collective level: the end of the world. The Koran refers to the end of the world as the "coming of the hour." Only God knows when this will occur. God's mercy protects humans from knowing all the details about imminent catastrophes:

> Narrated by Abu Ta'laba that the Messenger of God spoke: "Allah the Almighty has ordered religious

duties thus, do not neglect them. He has set limits thus, do not overstep them. He has prohibited things thus, do not commit them. He has remained silent about things, out of mercy for you, not through forgetting, thus do not make inquiries.

<div align="right">(Hadith 30)</div>

Like the revelations of John in the New Testament, the Koran describes signs that are also contained in several Hadiths. Because these signs may be symbolic in character, they should be separated from a historical perspective:

As small (by which I mean initial) signs of the hour, the religious knowledge disappears and ignorance (and thus also superstition) prevail; that alcohol is commonly consumed and the act of indecency (zina) becomes obvious; that entrusted goods are misappropriated and that good deeds become more and more rare and avarice will become dominant all over the world; that murders will increase and a human being will come to envy another for his death.

(Hadiths Number 80, 81, and 85, Volume I, Book 3)

Narrated by Hudaifa Al Rifari that the Messenger of Allah spoke: "The hour will not come until ten things have taken place: The pollution of the air (ad-dukhan), the appearance of the Dajjal (false Messiahs), the appearing of the animal (Ad-Daabba), the sunrise in the West, the return of Jesus, the devastation of the earth through Gog and Magog, three eclipses one following the other (of the moon or the sun) first in

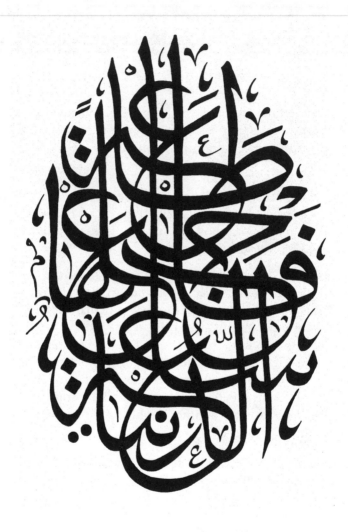

Calligraphy: "Life is like one hour. Thus, make sure God is satisfied with you."

the West, then in the East, and at last on the Arabian peninsula; and a fire in Yemen from which the people try to escape so that they finally walk into the sea in order not to burn to death."

<div align="right">(Hadith)</div>

The Hadiths do not distinguish which of these signs is most or least important. However, the sunrise from the West, the appearance of the animal, the appearance of the false Messiah, the return of Jesus, and the devastation of the earth through Gog and Magog are thought of as the major signs. Based on Surah 6.158, we must assume that it is useless to wait until the occurrences of the major signs in order to believe in God.

Ad-Daabba is an animal that will come out of the earth. This animal will move throughout the world, marking all believers and unbelievers (infidels) in preparation for the Last Judgment:

> *And when the Word is*
> *Fulfilled against them (the unjust),*
> *We shall produce from the earth*
> *A beast to (face) them.*
> *He will speak to them,*
> *For that mankind did not*
> *Believe with assurance*
> *In Our Signs.*

<div align="right">(Surah 27.82)</div>

Narrated by Abu Huraira that the Messenger of Allah spoke: "Ad-Daabba will come and will hold in its hands the staff of Moses and the ring of Solomon. With the ring of Solomon, the unbelievers will be marked on their nose (or will be branded); with the staff of Moses, the animal will touch the faces of the believers upon which they will become completely white and smooth. Then everybody will know who is a Kafir (unbeliever) and who is a Mu'min (believer)."

About the Dajjal, the false Messiah who will wander around and preach, we learn the following details from the Hadiths:

Narrated by Anas that the Prophet spoke: "Each prophet has narrated about this false Messiah. He is blind in one eye. On his forehead between his eyes, there are written three letters "kfr" and each Muslim will be able to read it."

(Hadith)

Another tradition says that the false Messiah has strong, curly, red hair and is blind in the right eye, which looks like a bulging white cluster.

Narrated by Nawa'as Ibn Sama'an: I heard Allah's Messenger saying, "The Dajjal is a young man with very strong curly hair. He is blind in one eye. Whoever sees him shall recite the first ten verses of the Surah Al Kahf [Surah 18] and remain steadfast. On his way between Iraqi and Syria, he will destroy everything that is left and right of him. He will stay for forty days,

yet these forty days will seem like one whole year. He will preach with the people and will achieve some miraculous things (as a test for the people given by God). He will make it rain and following his command, plants and grasses will shoot out of the earth. Cows and other animals will graze from it and will gain a well-fed appearance; yet the milk of these animals will be undrinkable.

"Other human beings to whom he will preach will not believe him. Upon this, he will devastate the earth so that it becomes as a barren desert landscape. Then he will go to the old, uninhabited, run-down houses and command the gold treasures hidden in them to follow him; and the gold will follow him like the bees their queen.

"Following this, he will meet a strong, young man whom he will split with his sword from head to toe and put him together once more the very next moment as if nothing had happened. What we will be dealing with is nothing more than a deceit to which the human beings will give in.

"At last, Jesus will appear, the son of Mary. He will descend from Heaven onto the white minaret of the Great Mosque in Damascus. This minaret has two saffron-colored ornaments. He will prop himself on the wings of two angels that will accompany him. In case he lowers his head, water will drip down; if he lifts

his head, drops like pearls will fall. An unbeliever who perceives his breath dies immediately; and his breath will reach as far as his view. He will go to the false Messiah, hold him back at the gate of the town Lydda [a village next to Jerusalem] and kill him. Upon this, Jesus will go to the people, whom God protected from the turmoil of the false prophet and who fought against him. Jesus will lay his hands on their faces and will take away all exhaustion from them. He will communicate to them on which level of Paradise they will find themselves on the day of the Resurrection.

"God will then speak to Jesus: 'Take charge of the believers and lead them to the mountain Al-Tur [next to Palestine]; for now I let the people go against whom each battle is senseless.' He then sends Gog and Magog, whose number is as great as the sands on the beach. And they stream towards them from all heavenly directions. The first ones among them that arrive at the lake of Genezareth will drink it empty and the last ones among them will not find a single drop in it because they are so numerous.

"These folks will arrive at the mountain Khamrim in Jerusalem. There, they will speak: 'Members of our folk have been killed here. Let us now kill whoever is in heaven.' Following these words, they will shoot with arrow and bow into the sky. God will return these arrows covered with blood so that they are kept in the belief that they have gained victory over each and everything that resides in heaven and on earth.

"Jesus and the believers will sit encircled in the mountain and will ask God to destroy these peoples. Upon this, God will send a certain kind of worm that will drill itself into the neck of Gog and Magog, which will lead to the death of both of them. Upon this event, Jesus will descend with the believers and will not find a single spot that is not dirty and of foul smell. They will pray a Du'a' [prayer of supplication] upon which a strong rain will fall which will then cleanse everything; this rain will be so strong that all buildings will collapse.

"God will then command the earth that it will surrender its fruits and treasures. From a pomegranate everybody will get sustenance and its core will be so large that all human beings will find protection from the sun in it. The milk of a she-camel and a cow will be enough for an entire population. Afterwards, God will send a smooth wind that will carry away the souls of all believers so that only the bad people will remain alive. These people are devoid of any feeling of shame; they are like cattle and carry out sexual intercourse in public.

"In this moment, the first horn will sound."

<div align="center">(Hadith Number 1,808, Volume II)</div>

The false Messiah will not be able to enter Medina because the city is guarded by angels. Gog and Magog, who are let loose during the last days, are mentioned several times in the Bible. They are identified by most of the neo-classical commentators of

The word "Kufr" or "Kfr" is a sign of the false Messiah, the Dajjal.

the Koran as the Mongols and Tartars. Along these same lines, the Prophet awoke from a dream and called out,

There is no God, beside God! You Arabs will be sorry, for mischief approaches. A small gap opened up today in the rampart against Gog and Magog!

This was later interpreted as the prophecy of the great Mongol invasion which destroyed the Abbasid empire and with it the political power of the Arabs.

On the other hand, the names "Gog" and "Magog" are generally understood as a common epithet for lawless tribes or for the impact of these destructive forces. They are also regarded as a symbolic representation of social and cultural catastrophes that will strike people shortly before the last hour.

According to the Koran, Gog and Magog have already appeared catastrophically once before in the history of mankind. A group people were being attacked by them until a man named Zul-Qarnain helped them:

Until, when he reached
(A tract) between two mountains,
He found, beneath them, a people
Who scarcely understood a word.
They said, "O Zul-qarnain!
The Gog and Magog (people)
Do great mischief on earth.
Shall we then render thee
Tribute in order that
Thou mightest erect a barrier
Between us and them?"

173

He said, "(The power) in which
My Lord has established me
Is better (than tribute).
Help me, therefore, with strength
(And labour). I will
Erect a strong barrier
Between you and them.
Bring me blocks of iron."
At length, when he had
Filled up the space between
The two steep mountainsides,
He said, "Blow (with your bellows)"
Then, when he had made
It (red) as fire, he said,
"Bring me, that I may
Pour over it, molten lead."
Thus were they made
Powerless to scale it
Or to dig through it.
He said, "This is
A mercy from my Lord,
But when the promise
Of my Lord comes to pass,
He will make it into dust;
And the promise of
My Lord is true."

(Surah 18.93-98)

Until the Gog and Magog (people)
Are let through (their barrier),
And they swiftly swarm
From every hill,
Then will the True Promise
Draw nigh (of fulfillment).
Then behold! the eyes
Of the unbelievers will
Fixedly stare in horror, "Ah!
Woe to us! we were indeed
Heedless of this; nay, we
Truly did wrong!"

(Surah 21.96-97)

No one knows who Zul-Qarnain was; it is assumed, however, that he was a ruler and not a prophet.

The Koran also narrates the return of Jesus close to the end of time:

"And (Jesus) shall be
A Sign (for the coming
Of) the Hour (of Judgment) . . ."

(Surah 43.61)

Additional details about the actions of Jesus upon his return can be learned from the Hadiths:

> Narrated by Abu Huraira: Allah's Apostle said, "By Him in Whose Hands my soul is, surely (Jesus) the son of Mary will soon descend amongst you and will judge mankind justly (as a Just Ruler); he will break the Cross and kill the pigs and there will be no Jizya (i.e., taxation taken from non-Muslims). Money will

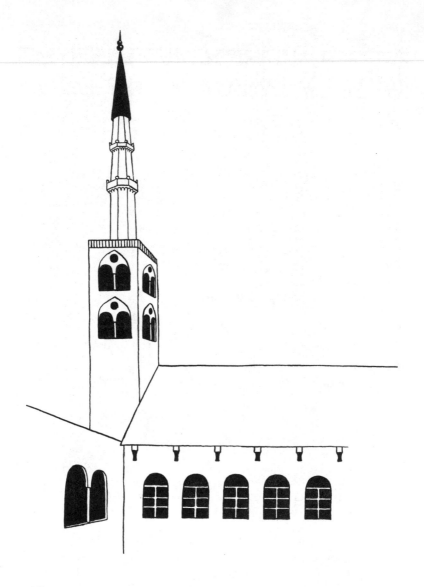

The eastern minaret of the Umayyad mosque in Damascus, Syria, called Isa-minaret because Jesus is supposed to descend there on Judgment Day.

be in abundance so that nobody will accept it, and a single prostration to Allah (in prayer) will be better than the whole world and whatever is in it." Abu Huraira added "If you wish, you can recite (this verse of the Holy Book): 'And there is none of the people of the Scriptures (Jews and Christians) but must believe in him (i.e., Jesus as an Apostle of Allah and a human being) before his death. And on the Day of Judgment He will be a witness against them.'"

(Hadith Number 657, Volume 4, Book 55)

According to another tradition, Jesus will marry, have children, and stay for forty-five years. After his death, he will be buried next to the grave of the Prophet Muhammad and will rise from a grave between those of Abu Bakr and Omar (two of Muhammad's closest companions) together with Muhammad on the Day of Resurrection. The graves of these three are situated in the Mosque of Prophets, Masjid an-Nabawi, in Medina.

The Day of Judgment is introduced in this way: The angel Israfil will blow the Sur (horn). With the first sounding of the trumpet, the universe and all its forms of life will be destroyed. The events at the end of time are presented most vividly in the following Surahs:

> *When the sun*
> *(With its spacious light)*
> *Is folded up;*
> *When the stars*
> *Fall, losing their luster;*
> *When the mountains vanish*

(Like a mirage);
When the she-camels
Ten months with young,
Are left untended;
When the wild beasts
Are herded together
(In human habitations);
When the oceans
Boil over with a swell;
When the souls
Are sorted out;
(Being joined, like with like);
When the female (infant),
Buried alive, is questioned
For what crime
She was killed;
When the Scrolls
Are laid open;
When the World on High
Is unveiled;
When the blazing fire
Is kindled to fierce heat;
And when the Garden
Is brought near; —
(Then) shall each soul know
What it has put forward.

(Surah 81.1–14)

The line "being joined, like with like," means when souls are joined once again with their bodies. The lines "when the female (infant), buried alive" refer to the pagan Arabs who killed their newborn daughters.

When the Earth is
Shaken to her (utmost) convulsion,
And the Earth throws up
Her burdens (from within),
And man cries (distressed):
"What is the matter with her?"
On that Day will she
Declare her tidings,
For that thy Lord will
Have given her inspiration.
On that Day will men
Proceed in companies sorted out,
To be shown the deeds
That they (had done).
Then shall anyone who
Has done an atom's weight
Of good, see it!
And anyone who
Has done an atom's weight
Of evil, shall see it."

(Surah 99)

(It will be) the Day
When no soul shall have
Power (to do) aught for another . . .

(Surah 82.19)

The Day that
(All) things secret
Will be tested,
(Man) will have

No power,
And no helper.

(Surah 86.9–10)

When Israfil blows the trumpet a second time, the Resurrection will occur, and everyone will rise from the grave and gather together. The risen will appear in different groups according to their denomination. From the Koran and the Hadiths, we know that Muslims will be overwhelmed (referred to as experiencing a quelling) and will undergo ritual cleansing at the time of Resurrection.

> Narrated by Nu'aim Al-Mujmir: I climbed with Abu Huraira onto the roof of the mosque; there he finished his Wudzu [ablution or ritual purification] and said the following: "I heard the Prophet speak: 'The members of my ummah [community] will be called upon on the Day of Resurrection and they will appear with a marking on the forehead (as traces of quelling) and with a ring around their ankles (as traces of Wudzu)...'"

(Hadith)

According to another Hadith, Muslims are the last inhabitants of this earth and the first ones on the Day of Resurrection. The people who receive their life report in their right hand will belong to the inhabitants of Paradise; those who receive their book in their left hand will belong to the denizens of Hell.

On the Day of Judgment, each and every one will have to bear witness; not only living beings but also the earth itself and even the individual limbs will bear witness.

The deeds will be judged according to their intention, yet no human being will be saved by his deeds alone. Everyone will be dependent on the mercy of God because no one is entirely free of sin. The mercy of God is emphasized in the Koran:

> *To God. He hath inscribed*
> *For Himself (the rule of) Mercy.*

(Surah 6.12)

> *Say: "O my Servants who*
> *Have transgressed against their souls!*
> *Despair not of the Mercy*
> *Of God: for God forgives*
> *All sins: for He is*
> *Oft-Forgiving, Most Merciful."*

(Surah 39.53)

Islam considers unbelief (Kufr) and polytheism (Shirk) to be unforgivable sins, so one must give them up during one's lifetime. The descriptions of Paradise and of the Fires of Hell are symbols, allegorical descriptions of our earthly experience of life.

> *Now no person knows*
> *What delights of the eye*
> *Are kept hidden (in reserve)*
> *For them as a reward*
> *For their (good) Deeds.*

(Surah 32.17)

The Mosque of the Prophets (Masjid an-Nabawi) in Medina, Saudi Arabia, is located at the spot where Muhammad's house once stood and where the grave of the Prophet can be found.

The sight of God is finally granted to all inhabitants of Paradise. Paradise itself is described in the Koran as several gardens of Paradise, the highest level of which is called Al-Firdaus. According to tradition, the throne of God is situated above this level and from there the rivers of Paradise have their source.

> *God hath promised to Believers,*
> *Men and women, Gardens*
> *Under which rivers flow,*
> *To dwell therein,*
> *And beautiful mansions*
> *In Gardens of everlasting bliss.*
> *But the greatest bliss*
> *Is the good pleasure of God;*
> *That is the supreme felicity.*

(Surah 9.72)

> *But give glad tidings*
> *To those who believe*
> *And work righteousness,*
> *That their portion is Gardens,*
> *Beneath which rivers flow.*
> *Every time they are fed*
> *With fruits therefrom,*
> *They say, "Why, this is*
> *What we were fed with before,"*
> *For they are given things in similitude;*
> *And they have therein*
> *Companions pure (and holy);And they abide therein (forever).*

(Surah 2.25)

A plate with a flower motif.

Most authors tend to ignore the afterlife of normal women when translating the Koran and describing Paradise. Instead, they dedicate themselves to the verses describing the virgins of Paradise, the hur. The information that women will also have their own special companions in Paradise is normally overlooked and glossed over.

On the other hand, Hell is described as a place of great horror. It has seven gates through which people enter. As soon as their skin is burnt by the fires of Hell, it will be restored in order to expose the condemned once more to these tortures. There will be nothing to drink other than boiling water and no food other than thorn bushes. However, according to tradition, some people are allowed to leave the fires of Hell after a certain amount of time:

> Narrated by 'Imran bin Husain: The Prophet said, "Some people will be taken out of the Fire through the intercession of Muhammad. They will enter Paradise and will be called Al-Jahannamiyin (the hell fire people)."
>
> (Hadith Number 571, Volume 8, Book 76

Calligraphy: "There is no god but Allah."

The Prayer As-Salah

"Verily, I am God.
There is no god but I.
So serve thou Me (only)
And establish regular prayer
For celebrating My praise."

(Surah 20.14)

When My servants
Ask thee concerning Me,
I am indeed
Close (to them). I listen
To the prayer of every
Suppliant when he calleth on Me;
Let them also, with a will,
Listen to My call . . .

(Surah 2.186)

Nay, seek (God's) help
With patient perseverance
And prayer.
It is indeed hard, except
To those who bring a lovely spirit,
Who bear in mind the certainty
That they are to meet their Lord,
And that they are to return to Him.

(Surah 2.45–46)

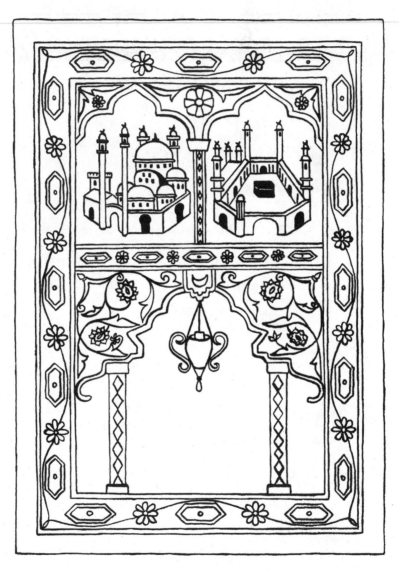

A prayer rug.

. . . But when ye are free
From danger, set up
Regular prayers:
For such prayers
Are enjoined on Believers
At stated times.

(Surah 4.103)

The affirmation of the unity of God (Tauhid) is the first pillar of Islam. Prayer is the second pillar. It is obligatory for all Muslims. It is the direct connection between the individual and his Creator. During prayer, the worshipper understands the transitory nature of the present world and reflects on his confidence in God through the virtues of honesty and repentance. Prayer does more than worship God. It also purifies the heart and the soul by examining one's conduct, by acknowledging possible misbehavior before God, and by repenting and asking for forgiveness. Thus, prayer can be understood as a reflection or even as a symbol of one's overall belief.

And establish regular prayers
At the two ends of the day
And at the approaches of the night;
For those things that are good
Remove those that are evil.
Be that the word of remembrance
To those who remember (their Lord).

(Surah 11.114)

. . . Thou canst but
Admonish such as fear
Their Lord unseen
And establish regular Prayer.
And whoever purifies himself
Does so for the benefit
Of his own soul; and
The destination (of all)
Is to God.

(Surah 35.18)

Narrated by Abu Huraira: I heard Allah's Apostle saying, "If there was a river at the door of anyone of you and he took a bath in it five times a day, would you notice any dirt on him?" They said, "Not a trace of dirt would be left." The Prophet added, "That is the example of the five prayers with which Allah blots out (annuls) evil deeds."

(Hadith Number 506, Volume 1, Book 10)

The prayer is also regarded as a protection against all negative influences. This is clearly shown in Surah 113 (Sura-t-al-Falaq, the Dawn) and Surah 114 (Sura-t-an-Nas, Mankind).

The physical and spiritual attitude during prayer expresses the fear of the Lord and humility before God. One remembers one's needs and one's dependence on God. By approaching God with a plea, the human being also accepts the fact that he needs help. This insight leads to modesty. Under certain circumstances, the lack of a plea for help can be seen as a sign of misplaced, exaggerated pride and of complacency.

Narrated by Abu Huraira: I heard the Messenger of Allah say: "Allah is enraged about the one who does not request anything from Him."

(Hadith 36)

Narrated by Abu Huraira: Allah's Apostle said, "Our Lord, the Blessed, the Superior, comes every night down on the nearest Heaven to us when the last third of the night remains, saying: 'Is there anyone to invoke Me, so that I may respond to invocation? Is there anyone to ask Me, so that I may grant him his request? Is there anyone seeking My forgiveness, so that I may forgive him?'"

(Hadith Number 246, Volume 2, Book 21)

Prayer is performed five times a day; the times of the prayers vary according to the position of the sun, which changes with the seasons. The morning prayer at dawn (Fajr) consists of two Rak'ah (sections), the midday and afternoon prayers ('Asr) each consists of four Rak'ah, the evening prayer (Maghrib) of three, and the night prayer (Isha) of four Rak'ah. Travelers can use the "traveling prayer" which shortens the prayers from four Rak'ah to two Rak'ah.

The three kinds of prayers include: the five obligatory prayers (Fard), the recommended Sunnah prayer, and the voluntary supplications (Du'a'). The additional, voluntary short service (Dhikr) is not a prayer, though it is often performed following the main prayer. Examples of Sunnah prayers are the Tarawih prayer in the fasting month of Ramadan and the festivity prayer (Salat-ul-'Id), performed during the breaking of the fast

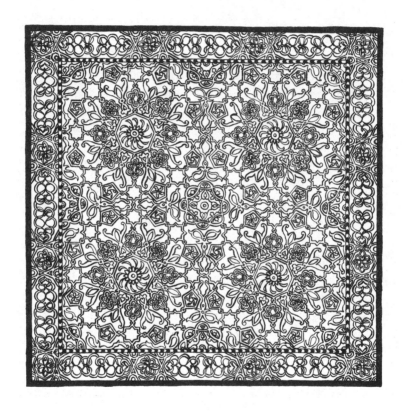

A ceiling ornament in the vault of the main entrance of the Umayyad Mosque in Damascus, Syria.

('Id al-Fitr) at the end of Ramadan as well as with the sacrificial festival ('Id al-Adzha) on the tenth day of each of the twelve months (Dhul-Hijrah) of the Islamic lunar calendar. The prayer for divine inspiration (Salah tul-Istikhara) is a special form of supplication.

Regardless of nationality, Muslims say the obligatory prayer in Arabic. This is considered the spiritual mother tongue of all Muslims because the Koran was revealed in Arabic, and the prayer consists of the recitation of the Koran verses. Islamic jurisprudence (Fiqh) gives special dispensation to converts. They are allowed to recite the translation of the particular Koran verse in their own language until they are able to speak them in Arabic. However, the worshipper is responsible for translating the prayer of supplication into his mother tongue.

In Islamic-oriented countries, the beginning of each praying time is announced by the Muezzin, who gives the call for prayers (Adhan) from the minarets of the mosques. These read as follows:

Allahu Akbar! (God is the Greatest!); Ashadu an la ilaha ill-Allah (I bear witness that nothing deserves to be worshipped except God); Ashadu anna Muhammad-an Rasulu-Ilah (I bear witness that Muhammad is the Messenger of God); Hayya'ala-s-salah! (Come to prayer).

The congregational prayer (Iqamah) that is recited shortly afterwards indicates the beginning of the prayer session and corresponds to the Adhan. The words "Quad qamati-salah" (the prayer is ready) are added to the final "Allahu Akbar."

Friday is the Muslim holy day; it is comparable to Sunday in the Christian world. All Muslim men are required to recite the midday prayer on Friday in a mosque with the rest of the Muslim community. This prayer is called Jumuah prayer. Unlike the

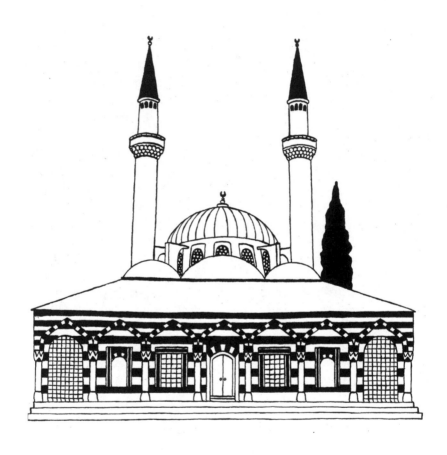

The Suleymaniye Mosque in Damascus, Syria.

normal midday prayer, it consists of only two Rak'ahs because
the prayer session also includes a Khutba (sermon). Although
they are not required to do so, Muslim women may participate
in the Friday prayer. Muhammad clearly indicated this in several
Hadiths. However, only a few women do so.

For the Khutba, the Imam (prayer leader) enters the pulpit
(Minbar) situated on the Qiblah wall. This is the wall that indi-
cates the direction of prayer. In most cases, the Khutba involves a
topic corresponding to verses of the Koran and Hadiths. After the
Khutba, the Imam descends from the pulpit and positions himself
in the prayer niche (Mihrab), located in the Qiblah wall. He does
this so that he is praying on the same level as the rest of the
community. Unlike Christianity, Islam has no clerical structures
or hierarchies. Any Muslim who has a good command of the
writings in the Koran and the Hadiths can be an Imam; no
special social rank is required.

For all Muslims, the direction of prayer (Qiblah) is the Ka'bah
in Mecca:

We see the turning
Of thy face (for guidance)
To the heavens; now
Shall We turn thee
To a Qibla that shall
Please thee. Turn then
Thy face in the direction
Of the sacred Mosque:
Wherever ye are, turn
Your faces in that direction.
The People of the Book

The pulpit (Minbar), viewed from the side of a staircase passage.

Know well that that is
The truth from their Lord.
Nor is God unmindful
Of what they do.

(Surah 2.144)

The worshipper is not penalized if he is not able to ascertain the correct direction while on vacation:

To God belong the East
And the West; whithersoever
Ye turn, there is the Presence
Of God. For God is All-Pervading,
All-Knowing.

(Surah 2.115)

In the beginning, Muslims had no special direction of prayer. Then, they prayed towards Jerusalem (Al Quds). However, since the revelation of Surah 2.144, the direction of prayer is towards the Ka'bah in Mecca.

The ritual cleanliness of the body is a precondition for the validity of prayer. This may be achieved through a partial cleansing (Wudu') or a whole purification (Junub) of the body:

O ye who believe!
When ye prepare
For prayer, wash
Your faces, and your hands
(And arms) to the elbows;
Rub your heads (with water);
And (wash) your feet

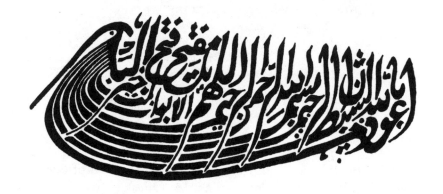

Calligraphy: "I seek refuge in God from Satan, the rejected. I begin in the name of God who is most merciful, the Mercy-giving."

To the ankles.
If ye are in a state
Of ceremonial impurity
Bathe your whole body.
But if ye are ill
Or on a journey,
Or one of you cometh
From offices of nature,
Or ye have been
In contact with women
And ye find no water,
Then take for yourselves
Clean sand or earth,
And rub therewith
Your faces and hands.
God doth not wish
To place you in a difficulty,
But to make you clean,
And to complete
His favour to you,
That ye may be grateful.

(Surah 5.6)

Wudu' and Junub follow a specific ritual. At the beginning of the Wudu', the worshipper says,

A'udhu bi'llahi mina'sh-shaytani'r-rajim. Bismi'llahi'r-Rahmani 'r-Rah (I seek refuge in God from Satan, the rejected. I begin in the name of God who is most merciful, the Mercy-giving).

The Wudu' consists of washing one's hands three times,

washing and rinsing one's mouth and nose three times, washing one's face three times, washing one's underarms three times (right side first); wiping one's head with wet hands once, cleansing the inside of both ears at the same time, and finally, washing one's feet three times (right foot first). The Wudu' must be repeated after excretions, flatulence, sleeping, and fainting.

Junub is necessary after intercourse, after a woman's menstruation, after a woman gives birth, and at death. In addition, all Muslims must do a whole body cleansing on Fridays. As with the Wudu', the Bismilla" is recited. First, one cleans the hands in the same manner as described with the Wudu'. Then, one washes the lower body with running water, using the left hand, first in the front, then in the back. Next, one washes the hands three more times. Then the procedure follows the general Wudu'. Afterwards, one rinses the head three times and pours water over the right, then the left shoulder, allowing the water to stream down and spread over the entire body. This is repeated two more times.

The right hand is considered clean, whereas the left is considered unclean. This has nothing to do with Satan. Actually, anyone who has ever visited Oriental countries can understand the reason. Simply stated, the use of toilet paper is not customary. Instead, after using the toilet, one uses special water supplies with hoses or water jugs next to the toilet to wash oneself, using the left hand:

> 'A'ishah said: The right hand of the Messenger of Allah, was for everything clean and for his food, and his left hand for cleaning after easing himself and for removing noxious things.
>
> (Hadith Number 12)

While the triple washing corresponds to the Sunnah, the actual obligation (Fard₤) is only one washing. The number three has no deep symbolic meaning, but odd numbers are preferred in Islam because the number one is an odd number (Witr) and symbolizes the uniqueness of God:

> From 'Ali: The Messenger of Allah says: "Allah is one, He loves what is one, therefore, perform the Witr [prayer], you people of the Koran.
>
> (Hadith Number 193)

Odd numbers or amounts are also preferred because, according to several Hadiths, the first verses of the Koran were revealed on one of the odd nights of the last ten days of the month of Ramadan. The special significance of this night, called Lai latu'l-Qadr, will be discussed in the chapter on fasting.

A further requirement is the ritual cleanliness of clothing, meaning that it has to be free of spots caused by human or animal excretions. Other spots do not make the clothes ritually unclean, but they should be avoided because the cloth needs to be clean at all times. In addition, one must also be properly covered. A man must be covered from the navel down to the top of the knees; normally, the man should be completely clothed so that his upper body is also covered. Furthermore, the clothing should not be tight from the waist down.

According to the Sunnah, because women are considered to be more visually "tempting," only their faces and hands may be seen. Their clothing should be loose so that it does not emphasize the body. Neither the Koran nor the Sunnah says that the woman should wear the chador, a very large shawl that covers the hair and

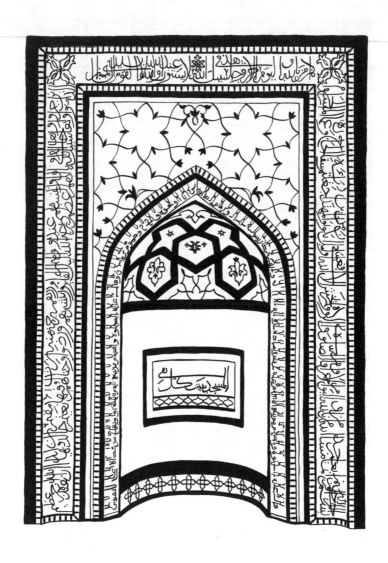

A prayer niche (Mihrab).

202

the face except for a small slit for the eyes. This kind of conceal-
ment is even prohibited during prayer and during the Hajj
because the face and the hands may not be covered.

The head scarf that Muslim women wear seems to be a partic-
ular thorn in the side of non-Muslims. This scarf is not a symbol of
oppression. Rather, it is the expression of a personal decision
concerning one's proper religious life. No one forces a woman to
wear a head scarf. Interestingly, when nuns wear special clothes,
people respect this visible symbol of their decision. On the other
hand, a Muslim woman's head scarf becomes a point of contention.
Non-Muslim societies often regard women who wear a head scarf
as oppressed people who have no free will. That these women are
not permitted to be professionals, which is true in some countries,
should not be generalized. The situation of these women cannot be
traced back to Islam; a distinction must be made between religion
and tradition. Furthermore, Islam encourages both men and
women to educate themselves. One of the Hadiths indicates that
the search for knowledge is an obligation for all Muslims.

Non-Muslim women in particular seem to regard the head scarf
as a threat to the emancipation of all women. These women should
have a similarly critical stance towards very liberal clothes that
display the female body rather than clothe it. These clothes appear
to be a much greater threat to women's emancipation because they
reduce a woman to a mere object.

A woman should not regard the head scarf as necessary.
However, the head scarf and modest clothes serve as a protec-
tion against sexual molestation, including suggestive eye contact
with men. It also serves as a sign of identification between
Muslim women:

O Prophet! Tell
Thy wives and daughters,
And the believing women,
That they should cast
Their outer garments over
Their persons (when abroad).
This is most convenient,
That they should be known
(As such) and not molested.
And God is Oft-Forgiving,
Most Merciful.

(Surah 33.59)

And say to the believing women
That they should lower
Their gaze and guard
Their modesty . . . that they should
Draw their veils over
Their bosoms and not display...

(Surah 24.31)

Before the arrival of Islam, Arabic women wore the scarves (Humur) mentioned in the last verse merely as adornment. The scarf was worn over a long shirt with a plunging neckline so deep that the bosom could be seen.

According to Asad, this verse does not refer to the use of the scarf but rather to the fact that the breasts of a woman should be covered. These two verses are the only passages of the Koran that discuss the clothing of women. The first verse is a reference to wearing a head covering.

From 'A'ishah: Asmah, the daughter of Abu Bakr, entered the house of Allah's Messenger and wore thin [transparent] clothes. He turned away from her and said: "O Asmah, when a woman has reached the age of menstruation it is not right that more than this and this can be seen of her," and he herewith pointed to his face and his hands.

(Hadith 61)

However, this Hadith is considered a weak one, meaning that it is not totally accepted. A more drastic and more aggressive treatment of women can be found in the New Testament. This discussion of women goes beyond clothing. In the first letter of Paul to Timothy (1 Timothy 2.9-15) and in the first letter of Paul to the Corinthians (1 Corinthian 11.5-13), women without a head covering are compared to whores ("shaved heads"). According to Paul, the sole purpose of a woman's life is to serve a man.

The Sufis, Islamic mystics, are also opposed to extravagant and sexually provocative clothes. For the Sufis, wearing modest clothes and a head covering has a much deeper significance. They consider clothes to be a protection of the aura (the ethereal energetic field that surrounds the human being). The protection helps prevent negative emotions such as envy and jealousy from passing through ethereal paths. The head covering protects the aura of the head (delicate organs are located at the temples and the fontanel). In addition, the Sufis believe the head covering symbolizes the covering of the hair out of respect for the uniqueness of God. Muhammad himself used to wear a turban to cover his head. Traditionally, free men always wore a head covering.

The Surah Al-Fatihah (the opening chapter).

Gradually, this began to change through Western influence.

Another condition for prayer is that the ground on which the worshipper prays should be clean. Although it is customary to remove one's shoes before entering a mosque in order to keep it free of street dirt, many Muslims also use a special prayer rug. The rugs often have depictions of the Ka'bah in Mecca, the Mosque of the Prophet in Medina (Masjid an-Nabawi), or the Cathedral of Rocks (Al-Aqsa-mosque) in Jerusalem (Al Quds).

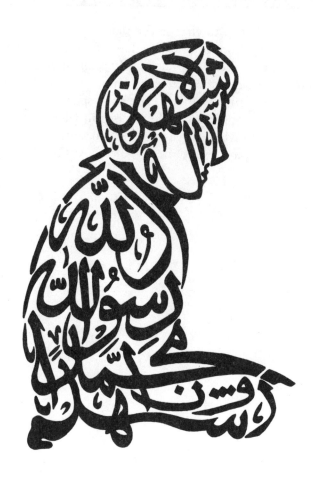

Calligraphy of the Tashahhud in which the worshipper pronounces the creed.

Prayer Sequence

Farāz — Obligatory Prayer

The prayer itself follows a sequence based on certain rules. The prayer begins with the opening Takbir in which the worshippers say, "Allahu Akbar," while lifting their hands. The hands are lifted only at the beginning of the prayer as a sign of its commencement. At this point, the worshippers have broken off any connection to the outside world. Mentally, they are standing before God. Now, the Al-Fatihah (the opening chapter) is presented with the Rak'ah of the obligatory prayer:

In the name of God, Most Gracious, Most Merciful.
Praise be to God,
The Cherisher and Sustainer of the Worlds;
Most Gracious, Most Merciful;
Master of the Day of Judgment.
Thee do we worship,
And Thine aid we seek.
Show us the straight way,
The way of those on whom
Thou hast bestowed Thy Grace,
Those whose (portion)
Is not wrath,
And who go not astray.

(Surah 1)

This Surah contains every aspect of what the Koran discusses: the power and uniqueness of God, the Day of Judgment, His mercy, His support, and legal guidance. The liturgical significance of Al-Fatihah corresponds to the Christian "Lord's Prayer." Not

many words are required because God knows the needs of humans much better than they do themselves. Following the Al-Fatihah, another Surah is recited. The worshipper decides which one, but Surah 112 (Al-Ikhlas, the Purity of Faith); the Surahs of protection (Al-Mu'awwadatan), Surah 113 (Surah-t-al-Falaq) and Surah 114 (Surah-t-an-Nas); and Surah 2.155 (the Throne Verse) are often recited.

After reciting the Takbir again, the Ruku' follows. One bends the upper body while saying, "Subhana Rabbiya 'l-'azim" (Glory be to my Lord, the Magnificent) at least three times. Afterwards, the worshipper returns to his standing position (Qiyam), pronouncing the words, "Sami'Allahu li-man hamidah" (Allah listens to him who praises him). This is followed with the Takbir and then by the Sujud (the prostration), reciting, "Rabba-na wa la-k-al-hamd" (Our Lord! all praise is due to Thee). At this point, the toes, the knees, the hands, the forehead, and the nose touch the ground. The forehead rests between the hands. The forearms are not allowed to touch the ground; they stand out diagonally with the elbow pointing upward. The upper body is not allowed to touch the ground either. This posture symbolizes the utmost humility and devotion before God as indicated by the Ruku'. After pronouncing the Takbir once more, the worshipper assumes a sitting position for prayer. This is followed by a second Sujud. The sequence from the opening Takbir to the second Sujud is described as a Rak'ah (stanza of the prayer). The second Rak'ah is performed in precisely the same manner as the first one. It consists of the recitation of two Surahs. The first is the Al-Fatihah, and the second is up to the individual. After the second Sujud of the second Rak'ah, the sitting position is assumed for a moment once again. Here the Tashahhud is spoken. It contains

210

the creed and is renewed with each prayer:

> At-tahiyyatu li-llahi wa-s-salawatu wa-tayyi batu (All
> services rendered by words and bodily actions and
> sacrifice of wealth are due to God). As-salamu' alai-ka
> ayyuha-n-nabiyyu wa rah matu-llahi wa barakatu-hu"
> (Peace be on thee, O Prophet! And the mercy of God
> and His blessings). As-salamu 'alai-na wa 'ala 'ibadi-
> llahi-s-salihin (Peace be on us and on the righteous
> servants of God). Ashhadu an la ilaha ill-Allahu wa
> ashhadu anna Muhammad-an 'abdu-hu wa rasuluh (I
> bear witness that none deserves to be worshipped but
> God, and I bear witness that Muhammad is His
> servant and His Apostle).

When reciting the creed, one lifts the index finger of the right hand while the hand continues to rest on the knee. According to one Hadith, the lifted index finger is a demonstration of strength against Satan. This gesture indicates that the worshipper is rejecting Satan. However, the lifted index finger is also a symbol for the uniqueness of God.

After prayers consisting of at least two more Rak'ahs, the worshipper stands up after this first part of the Tashahhud and prays. Using the sequence described above, the remaining Rak'ahs are recited except that the Al-Fathihah is recited only once. Afterwards, the entire Tashahhud is said again. When the prayers consist of two Rak'ahs, the entire Tashahhud is recited at this point. However, after the qa'dah, the following sentences are recited:

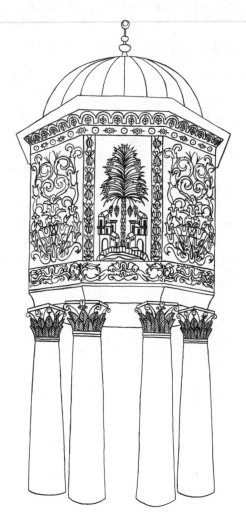

Bait mal al-muslimin, the Muslim treasure chamber, is situated in the inner court of the Umayyad Mosque in Damascus, Syria. In earlier times, the state treasury and the Zakat were kept in it.

Alla-imma salli 'ala Muhammad-in wa 'ala ali
Muhammad-in kama sallaita 'ala Ibrahima wa'ala ali
Ibrahima (O God! Exalt Muhammad and the true
followers of Muhammad as Thou didst exalt Abraham
and the true followers of Abraham). Alla-umma barik
'ala Muhammad-in wa 'ala ali Muhammad-in kama
barakta 'ala Ibrahima wa'ala ali Ibrahima; fil- 'alamin
(O God! Bless Muhammad and the true followers of
Muhammad as Thou didst bless Abraham and the true
followers of Abraham; in all worlds). Innaka Hamid-un
Majid (Surely Thou art Praised, Magnified).

The prayer concludes as the worshippers turn their heads first
to the right, then to the left saying: "As-salamu 'alai-kum wa
rahmatu-llah" (Peace be on you and the mercy of God). This is
described as Taslim and symbolizes the peaceful greetings to the
angels, the witnesses of the prayer.

Du'a' — Prayer of Supplication

The prayer of supplication (Du'a') is normally carried out with the
palms turned upwards, which places the individual in a receptive
posture. With the Salat-al-Istikhara, for example, one prays for the
right inspiration. It is only used when an individual faces a difficult
decision, and the correct choice is not obvious. This prayer of
supplication follows a certain sequence. It consists of two normal
Rak'ahs (see above), which must not be part of an obligatory
prayer. Instead, it must represent an additional, voluntary prayer,
requiring the ritual purification, assuming the correct direction
for prayer, etc. The actual prayer of supplication is as follows:

O Allah! I consult You, for You have all knowledge, and appeal to You to support me with Your Power and ask for Your Bounty, for You are able to do things while I am not, and You know while I do not; and You are the Knower of the Unseen. O Allah! If You know this matter [here one names the matter] is good for me both at present and in the future, or in my religion, in this life and in the hereafter, then fulfill it for me and make it easy for me, and then bestow Your Blessings on me in that matter. O Allah! If You know that this matter is not good for me in my religion, in this life and in the coming hereafter, then divert me from it and choose for me what is good wherever it may be, and make me be pleased with it.

(Hadith Number 487, Volume 9, Book 93)

For each prayer of supplication, the worshipper strokes his face with both hands. Instead of the general term "matter" used here, the worshipper would specify his concern. The right decision may be realized immediately as a spontaneous inspiration, or it will become clear in the days to follow. Under certain circumstances, dreams can show the right path.

Dhikr — Remembrance

The voluntary Dhikr (remembrance, devotion) involves reciting either the Ninety-Nine Most Beautiful Names of God or the words:

Subhana-k-Allah (Glory to Thee, O Allah our Lord!), Al-hamdu li-llahi (Praise be to God), and Allahu Akbar (God is the Greatest).

The Misbaha may be used as an aid. The simplest and best <u>Dh</u>ikr is the monotheistic creed; anything else loses significance as the worshipper concentrates on the uniqueness of God:

From Jabir: I heard Allah's Messenger say: "The best Dhikr is: la ilaha ill-Allah."

<div align="right">(Hadith Number 200)</div>

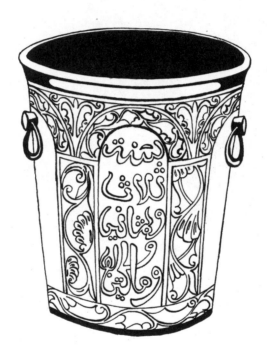

A Moroccan bushel (1866 A.D.), a measuring cup to determine the amount of alms (a needy person received four cups of wheat).

Giving Alms — Zakat

These are Verses
Of the Wise Book, —
A Guide and a Mercy
To the Doers of Good,—
Those who establish regular Prayer,
And give regular Charity,
And have (in their hearts)
The assurance of the Hereafter.
These are on (true) guidance
From their Lord; and these
Are the ones who will prosper.

(Surah 31.2-5)

And they have been commanded
No more than this:
To worship God,
Offering Him sincere devotion,
Being true (in faith);
To establish regular prayer;
And to practice regular charity;
And that is the religion
right and straight.

(Surah 98.5)

Even though the term "Zakat" is usually translated as "charity for the needy" or "alms," the literal translation is "purity," or more specifically "purification." Zakat is the third pillar of Islam and is usually mentioned in the Koran in the same verse as carrying out prayer, emphasizing its important role. Muslims believe that everything a human being has is a gift of God. As the Creator and

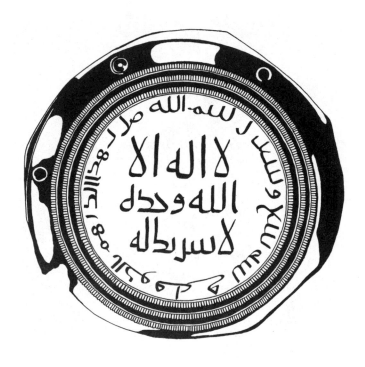

An ancient Islamic coin from the time of Caliph Abd al-Malik (685-705 A.D.).

Preserver of the universe, God is the sole owner of all things. Man is only the trustee for the goods entrusted to him. He has the obligation to "administer" these goods in a way that corresponds to God's will. The purpose of life is not to gain riches; on the other hand, property is not to be wasted either. Furthermore, money must not be used to exploit other people. This is the reason why Islam forbids interest rates and usury (Ribba):

> *O ye who believe!*
> *Devour not Usury,*
> *Doubled and multiplied;*
> *But fear God; that*
> *Ye may (really) prosper.*

(Surah 3.130)

> *Those who devour usury*
> *Will not stand except*
> *As stands one whom*
> *The Evil One by his touch*
> *Hath driven to madness.*
> *That is because they say,*
> *"Trade is like usury,"*
> *But God hath permitted trade . . .*

(Surah 2.275)

The Old Testament contains a prohibition against usury. Because Islam encourages a just and humane distribution of the treasures on earth, neither the stockpiling of capital nor an enforced redistribution of earthly goods is acceptable.

The Zakat is the individual's share of his fortune given in order to be purified. The payment of Zakat is obligatory when

A plant ornament from a Koran in Baghdad, Iraqi (approximately 1000 A.D.).

one's fortune reaches a certain size and one has had that amount for at least one lunar year (354 days). It is measured according to the type of fortune and its size. In most cases, it corresponds to about 2.5 percent of the wealth. This tribute is supposed to heal or purify the human being from his selfishness and greed.

The person who receives Zakat also experiences its purifying effect because it soothes negative emotions, such as envy or even hatred, towards the wealthy and those favored by destiny:

> *It is He Who hath made*
> *You (His) agents, inheritors*
> *Of the earth. He hath raised*
> *You in ranks, some above*
> *Others, that He may try you*
> *In the gifts He hath given you;*
> *For thy Lord is quick*
> *In punishment, yet He*
> *Is indeed oft-forgiving,*
> *Most Merciful.*

(Surah 6.165)

The ones authorized to receive Zakat are listed in the Koran. These include people who cannot support themselves or their family; people who have lost their ability to earn a living because of a disaster; and people who have had to assume debts for compelling reasons such as migrations. Also included are institutions such as educational facilities, hospitals, orphanages, and facilities that host those with questions about Islam:

Alms are for the poor
And the needy, and those
Employed to administer the (funds);
For those whose hearts
Have been (recently) reconciled
(To Truth); for those in bondage
And in debt; in the cause
Of God; and for the wayfarer.
(Thus is it) ordained by God,
And God is full of knowledge
And wisdom.

Surah (9.60)

Those who pay Zakat are not to advertise the fact that they have fulfilled their duty because such behavior would assume a craving for recognition. This would run counter to the concept of Zakat, purification from pride and haughtiness. In addition, such behavior would have a shameful effect on the recipients of the charity.

The Zakat al-Fitr is an obligatory charity for the needy connected with the festivity of breaking the fast ('Id al-Fitr) at the conclusion of the month of Ramadan. It may also be given during the month of fasting, but it must be given before people join the festivity prayer.

Begging is scorned in Islam because it is humiliating. This can be learned from the following Hadiths:

> Narrated by Umar: Allah's Apostle used to give me something but I would say to him, "Would you give it to a poorer and more needy one than I?" The Prophet said to me, "Take it. If you are given something from this property, without asking for it or having greed for

it, take it; and if not given, do not run for it."

(Hadith Number 552, Volume 2, Book 24)

Narrated by Abu Huraira: Allah's Apostle said, "The poor person is not the one who goes round the people and asks them for a mouthful or two or for a date or two, but the poor is he who has not enough [money] to satisfy his needs and whose condition is not known to others, that others may give him something in charity, and who does not beg of people."

(Hadith Number 557, Volume 2, Book 24)

The Zakat needs to be distinguished from Sadaqah (charity). This second type of charity is voluntary. The type and the amount that is given is left up to the individual.

> *Those who spend (freely),*
> *Whether in prosperity,*
> *Or in adversity;*
> *Who restrain anger,*
> *And pardon (all) men;*
> *For God loves those*
> *Who do good.*

(Surah 3.134)

By no means shall ye
Attain righteousness unless
Ye give (freely) of that
Which ye love, and whatever
Ye give, of a truth
God knoweth it well.

(Surah 3.92)

The alms can consist of any kind of good deed, even if it is only a good word. The person who donates money or tangible items should try to remain unrecognized so that he does not show off his generosity:

O ye who believe!
Cancel not your charity
By reminders of your generosity
Or by injury, like those
Who spend their substance
To be seen of men,
But believe neither
In God nor in the Last Day . . .

(Surah 2.264)

Fasting — Siyam and Saum

O ye who believe!
Fasting is prescribed to you
As it was prescribed
To those before you,
That ye may (learn)
Self-restraint . . .

(Surah 2.183)

Ramadhan is the (month)
In which was sent down
The Qur-an, as a guide
To mankind, also clear (signs)
For guidance and judgment
(Between right and wrong).
So every one of you
Who is present (at his home)
During that month
Should spend it in fasting . . .

(Surah 2.185)

Ramadan is the ninth month of the Islamic lunar calendar; it lasts for thirty days. Fasting starts before daybreak and ends after the sun has set. It is obligatory (Fardz) for every adult Muslim. Exceptions can be made for illness, menstruation, and for those who are traveling. However, each day of fasting missed must be made up for at a later date. A person who needs to take medicine regularly must give a needy person at least one meal daily. This can be accomplished by paying in kind or by providing a certain amount of money.

Muslims are expected to read the Koran at least once in its entirety during Ramadan. For this reason, the Koran is divided into thirty parts. Because the lunar year consists of only 354 days, it is eleven days shorter (or in a leap year, twelve) than the solar year. Thus, the month of Ramadan gradually travels through all seasons. As a result, Muslims are accustomed to the idea of fasting at any time of the year. If Ramadan had been fixed in a certain season of the sun calendar, for example, in December or January, Muslims living in the Northern Hemisphere would have a yearly advantage over those living in the Southern Hemisphere because fasting is easier in the winter. Dawn comes later, and dusk arrives earlier than in the summer for the entire length of Ramadan.

During the time from dawn until dusk, Muslims abstain from eating, drinking, smoking, intercourse, chewing or swallowing any kind of unnatural substances, and taking medicine by mouth, through the nose, or intravenously. In addition, Muslims must pay special attention to their words and deeds during this time.

> Narrated by Abu Huraira: The Prophet said, "Whoever does not give up forged speech and evil actions, Allah is not in need of his leaving his food and drink (i.e. Allah will not accept his fasting)."
>
> (Hadith Number 127, Volume 3, Book 31)

The morning meal before dawn is called Suhur; the breaking of the fast in the evening is called Iftar. According to the Sunnah, breaking the fast begins with one, three, or any other odd number of dates. Before starting the meal, the following words are spoken:

Allah humma laka sumna, wa 'ala rizqika aftarna. Bismi'llahi'r-Rahmani 'r-Rahim (O God! for Your sake have we fasted and now we break the fast with the food You have given us. I begin in the name of God who is most merciful, the Giver of Mercy).

An evening prayer follows the Iftar, and then a real dinner is usually served. During this meal, people drink generous amounts of fluids.

Fasting helps humans become more conscious of their dependence on God. While fasting, Muslims remember that it was God who created Man with his physical and spiritual needs as well as the means to satisfy these needs. In addition, fasting helps those who are prosperous understand the needs, the hunger, and the thirst of the poor. They are thus able to summon up more compassion and understanding for the poor.

The advantages of fasting from a medical point of view are discussed in great detail in specialized literature. However, it is the spiritual significance that receives the emphasis. Muslims understand that it is wrong (and not only from a medical point of view!) to make dinner during Ramadan so plentiful and rich that it seems to contradict the concept of fasting, the entire idea of which lies in self-control.

The voluntary Tarawih prayer is recited after the night prayer during Ramadan. It consists of eleven Rak'ahsl. Another specialty of the month of fasting is the Lailatu'l-Qadr (the night of grandeur or majesty):

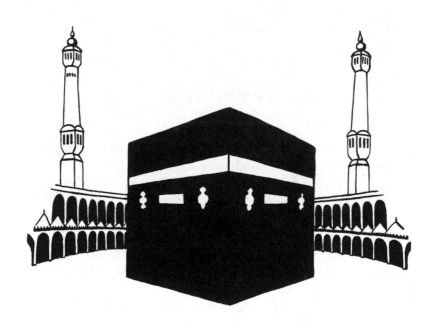

The Ka'bah in Mecca.

We have indeed revealed
This (Message)
In the Night of Power.
And what will explain
To thee what the Night
Of Power is?
The Night of Power
Is better than
A thousand months.
Therein come down
The angels and the Spirit
By God's permission,
On every errand,
Peace! . . . This
Until the rise of Morn!

(Surah 97)

Narrated by 'Aisha; Allah's Apostle said, "Search for the Night of Qadr in the odd nights of the last ten days of Ramadan (Witr)."

(Hadith Number 234, Volume 3, Book 32)

On this mystic night, the first verses of the Koran (Surah 1-5) were revealed to Muhammad. Muslims assume that this is the twenty-seventh night of the month of Ramadan, thirteen years before the emigration of the prophet from Mecca to Medina (Hijrah) in 622 A.D. This night symbolizes the connection between this world and the world beyond. On this night, the divine revelation of the Koran was delivered by the angels, particularly by the angel Gabriel, the one referred to as the "Spirit." The term Lailatu'l-Qadr can also be translated as the "Night of Power"

because on this night, God's decisions are given for the year.

According to tradition, the Lailatu'l-Qadr can be recognized because it appears brighter than on other nights, and the following sunrise seems to be brighter than on other mornings.

In several Hadiths, Muhammad recommends that people spend the night in prayer. This is important because Gabriel and his angels descend during the night, helping those who ask for a blessing from God:

> Narrated by Abu Hureira: Allah's Apostle said, "Whoever establishes the prayers on the night of Qadr out of sincere faith and hoping to attain Allah's rewards (not to show off) then all his past sins will be forgiven."
>
> (Hadith Number 34, Volume 1, Book 2)

> Narrrated by Abu Huraira: Allah's Apostle said, "Whoever observes fasts during the month of Ramadan out of sincere faith, and hoping to attain Allah's rewards, then all his past sins will be forgiven."
>
> (Hadith Number 37, Volume 1, Book 2)

Aside from the duty of fasting during Ramadan, voluntary fasting is permitted except on the two Islamic festivals 'Id al-Fitr and 'Id al-Adha as well as on holidays that are not part of Ramadan.

The Pilgrimage to Mecca — Hajj

Remember We made the House
A place of assembly for men
And a place of safety;
And take ye the Station
Of Abraham as a place
Of prayer; and We made a Covenant
With Abraham and Isma'il,
That they should sanctify
My House for those who
Compass it round, or use it
As a retreat, or bow, or
Prostrate themselves (therein
In prayer).

(Surah 2.125)

Each Muslim should make the pilgrimage to the Ka'bah, the house of God, at least once in his life, if his financial situation and health permit. We must distinguish between the Hajj, the great pilgrimage (Hajj akbar) and the 'Umrah (Hajj asrar; the lesser pilgrimage). For the 'Umrah, the worshipper circles the Ka'bah seven times and then crosses the area that separates the hills Safa and Marwah seven times.

The 'Umrah can be performed alone and at any time; on the other hand, the Hajj takes place within the community at an appointed time, namely from the first to the tenth day of Dhul-Hijrah, the pilgrimage month.

For Muslims, The Ka'bah symbolizes the local origin of the

The Black Stone of the Ka'bah in its silver setting.

light of Islam. It is the spot where the divine revelation was given to the people, first through Abraham and Ishmael and then through Muhammad. The denotation "Ka'bah" refers to the dice-shaped appearance of the first house of divine worship. In one corner of the Ka'bah, the so-called Black Stone is walled in. We assume that it was the first stone of the foundation wall of the Ka'bah when Abraham and Ishmael laid the foundation together. Although the Black Stone of the Ka'bah is not mentioned in the Koran, it is mentioned in the Hadiths.

Both the 'Umrah and the Hajj begin with consecration (Ihram). Ihram actually begins for foreign visitors even before entering Mecca. For example, for the people of Medina, it begins in Dhul Hulaifa; for the people from Palestine, it begins in Al-Juhfah; for the people from Najd, it begins in Qarnul Manazil; and for the people from Yemen, it begins in Yalamlam. These places are points of origin for the Hajj for the local people and transition places for travelers who want to perform the Hajj or the 'Umrah.

At the beginning of Ihram, the pilgrim must display the intention to perform the pilgrimage or to perform the 'Umrah. With the Ihram, the pilgrim must recite the Talbiyah:

> Here am I, O Allah, here am I in Thy presence; there is no associate with Thee, here am I; surely all praise is Thine and all favors are Thine and the kingdom is Thine, there is no associate with Thee."

Following the recitation of the Talbiyah, the pilgrim performs the ritual cleansing. Instead of regular clothes, the male pilgrim puts on two seamless white pieces of cotton sheets. These cover him only from the waist down. Women are allowed to wear their

ordinary clothes, yet they usually wear only a long, simple dress with the traditional head covering. Wearing seamless white cotton sheets symbolizes death: this is the way a human is wrapped in a shroud. Thus, the pilgrim becomes conscious of his own mortality. Symbolically, the experience reflects what happens after death, when one must account for one's deeds on the Day of Judgment. One of the Hadiths says that humans will feel as if reborn after the Hajj:

> Narrated by Abu Huraira: The Prophet said, "Whoever performs Hajj for Allah's pleasure and does not have sexual relations with his wife, and does not do evil or sins, then he will return after Hajj free from all sins as if he were born anew."
> (Hadith Number 596, Volume 2, Book 26)

The uniformity of clothes removes social distinctions and demonstrates the equality of all people before God. Thus, each year, the pilgrimage reaffirms the brotherhood (and sisterhood) of Muslims without regard for class, race, or language. In the Koran, different languages and races are emphasized as signs of God:

> *And among His Signs*
> *Is the creation of the heavens*
> *And the earth, and the variations*
> *In your languages*
> *And your colors. Verily*
> *In that are Signs*
> *For those who know.*

(Surah 30.22)

During the consecration, the pilgrim must remain detached from earthly life. He is not allowed to perfume himself, to cut his hair or nails, nor to have sexual intercourse; any of these would end the state of consecration or adversely affect it.

In the holy district of Mecca (Haram), the pilgrim says a prayer consisting of two Rak'ahs. Then, the pilgrim performs the circumambulation of the Ka'bah seven times. He moves in a counterclockwise direction so that he finds himself on the right hand of the Ka'bah. This circumambulation of the Ka'bah is accompanied by specific prayers. The point of origin of the procession is the Black Stone.

The circumambulation of the Ka'bah reflects the rotation of the sun through the planets or the rotation and approach of the human being to his spiritual center, his belief. Thus, the circumambulation of the Ka'bah is a parable of the microcosm and the macrocosm. During the circumambulation, the pilgrim should approach the Ka'bah and kiss or touch the Black Stone or at least look in its direction and point at it:

> Narrated by Abis Ibn Rabi'ah: Umar came to the Black Stone kissed it and said: "I know quite well that you are only a stone that is neither useful nor harmful. If I had not seen it with my own eyes that the Prophet kissed you thus I would not have kissed you."
>
> (Hadith)

Particular attention is not given to the stone itself, but touching it symbolizes the physical touch of all the people who have ever touched or kissed it, back to the time when the Prophet himself did so. This physical affection symbolizes the kiss

Arabic scripture: "Nothing deserves to be worshipped except Allah, He is One and has no associate; His is the kingdom and for Him is praise, and He has power over all things. He calls into life and brings death, but He himself is living and immortal. He has the good things at his disposal, and He is almighty."

of a sibling because all Muslims are considered brothers and sisters.

After the circumambulation, the pilgrims drink water from the fountain of Zamzam. A tale is attached to this act: Abraham received the order from God to leave his wife Hagar and his young son Ishmael on the old caravan road towards Yemen so that the place would be inhabited once again. In the bare desert, Hagar ran desperately back and forth between the hills of Safa and Marwah searching for water until an angel appeared to her. The angel brought her to the place on which Ishmael lay. At this place, a spring suddenly burst out of the ground. This place is called Zamzam and still exists today. Because there was water, travelers settled, and the town of Mecca developed. After the pilgrims drink from the source of Zamzam, they walk quickly back and forth between the hills of Safa and Marwah three times:

> *Behold! Safa and Marwa*
> *Are among the Symbols*
> *Of God. So if those who visit . . .*

(Surah 2.158)

Because of the mass of people and the heat in Mecca, the pilgrims drink water from the Zamzam fountain after the circumambulation. Then, they begin walking back and forth between the hills. Strictly speaking, the walk between al-Safa and al-Marwah would precede the drinking because the walk honors Hagar's search for water.

Afterwards, the pilgrims move towards 'Arafat Mountain, reaching the town of Mina after sunset. After sunrise, they continue their walk to 'Arafat where the believers symbolically

step before God and declare their absolute devotion and unlimited obedience. Standing on the mountain on the ninth day of pilgrimage (Wuquf) is the high point of the Hajj. The pilgrims spend the time from midday until sunset in prayer and devotion.

After sunset, the pilgrims leave the mountain and travel to Muzdalifah and then on to Mina, where the symbolic stoning of Satan takes place. Each worshipper throws twenty-one or forty-nine stones (depending on tradition) in the direction of three columns. This stoning reminds the worshippers of Abraham. In his dream, God ordered him to sacrifice his son. Satan diverted him three times while he was on his way to the sacrificial site with Ishmael. Abraham and Ishmael expelled Satan with stones.

On the tenth day, the pilgrims slaughter sacrificial animals. This is commonly celebrated as a sacrificial festival ('Id al-Adha) and reminds the pilgrims once more of the testing of Abraham. In the end, Abraham sacrificed a lamb instead of Ishmael. The planned sacrifice of Ishmael instead of Isaac is one of the most important points of dispute between Jews and Muslims. Genesis 22 of the Old Testament claims that Isaac was supposed to be sacrificed and that God had made a bond with him. However, this contradicts the rights of the firstborn. This point is particularly important with the Semitic people. Deuteronomy 21.15-17 clearly states that the firstborn, no matter whether from an "unloved" second wife, holds the status of the firstborn and the special rights connected to it.

According to the tradition of the Old Testament, Ishmael's position as the firstborn is undisputable. Would his right as the firstborn have been ignored? In Genesis 17, God introduced the circumcision of male descendants as a sign of his Covenant with

Abraham. Ishmael was circumcised before Isaac, the second son, was born. Regardless of this disagreement, we are dealing with our willingness to endure sacrifice.

> So when they had both
> Submitted their wills (to God),
> And he had laid him
> Prostrate on his forehead
> (For sacrifice),
> We called out to him,
> "O Abraham!
> Thou hast already fulfilled
> The vision!" Thus, indeed,
> Do We reward
> Those who do right.
> For this was obviously
> A trial . . .

<div align="right">(Surah 37.103–106)</div>

Men shorten their hair or shave it off. This ritual corresponds to shaving the hair of a newborn and is considered a symbol of a new beginning. Many other cultures also encourage haircuts or a change of hairstyle when a new phase of life begins. In this case, everyone is prepared to change, to create a new beginning.

Shaving the hair can also be regarded as a substitute sacrifice for those who cannot afford to sacrifice an animal. Some Hadiths indicate that one who does not sacrifice an animal on 'Id al-Adha cuts his hair and nails on the tenth day of the Dhul-Hijrah and receives the same reward from God as one who offers a sacrifice

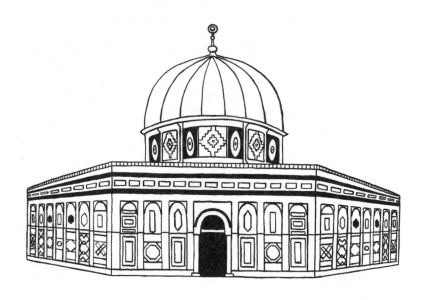

and circles the Ka'bah seven times.

Finally, the worshipper circles the Ka'bah seven more times. This is called the farewell circumambulation. It concludes the pilgrimage.

Another popular but not obligatory goal is to visit the Dome of the Rock and the Al-Aqsa mosque in Jerusalem. The octagonal Dome of the Rock was built during the rule of Calif -Abd Al Malik, who ruled from 685–705 A.D. Inside is a carved rock. This is considered to be the site from which Muhammad ascended to heaven (Mi'raj). Jews believe this rock was the site of the sacrifice of Isaac and a platform in Solomon's temple.

In his ascent to heaven, also called the nocturnal journey, Muhammad flew through the air to Jerusalem. At the rock, he met the former Messengers of God, Abraham, Moses, Jesus, and all the others. He prayed together with all of them. Afterwards, God led him gradually up to the seventh heaven and introduced him to many mysteries. In each of the different heavens, he encountered one of the former prophets whom he questioned and who referred him to the subsequent prophet in the next higher level of heaven until he arrived at the seventh level, the highest heaven, where he experienced the presence of God.

A tile ornament from the Alhambra in Granada, Spain.

Jihad

Fight in the cause of God
Those who fight you,
But do not transgress limits,
For God loveth not transgressors.

(Surah 2.190)

Those who believe, and suffer
Exile and strive with might
And main, in God's cause,
With their good and their persons,
Have the highest rank
In the sight of God:
They are the people
Who will achieve (salvation).
Their Lord doth give them
Glad tidings of a Mercy
From Himself, of His good pleasure,
And of Gardens for them,
Wherein are delights
That endure."

(Surah 9.20–21)

Jihad means "struggle" or "strive." The translation of "Holy War" is not accurate. This was a term used by others, based on the medieval Crusades. The media uses Jihad to stir up unfounded fears.

Islam differentiates between two struggles: the lesser Jihad (Jihad al-asrar) and the great Jihad (Jihad al-akbar). The lesser Jihad is the struggle against external forces. It is not allowed as an

offensive attack, only as a defense. This is the meaning of Surah 2.190. In connection with the lesser Jihad, journalists quote only the first half of the following verse. This results in the fear of an invasion by saber-swinging Arabs:

> *And slay them*
> *Wherever ye catch them,*
> *And turn them out*
> *From where they have*
> *Turned you out;*
> *For tumult and oppression*
> *Are worse than slaughter;*
> *But fight them not*
> *At the Sacred Mosque,*
> *Unless they (first)*
> *Fight you there;*
> *But if they fight you,*
> *Slay them.*
> *Such is the reward*
> *Of those who suppress faith.*
> *But if they cease,*
> *God is Oft-forgiving,*
> *Most Merciful.*

(Surah 2.191–192)

The verse refers to the struggle in the area of Mecca. At the time, Mecca was still in the hands of pagan Arabs who did not allow Muslims to carry out the pilgrimage. The first half of the sentence, "slay them wherever ye catch them," is only valid in fights, meaning armed conflicts that are already taking place. Once again, we emphasize that the word "unbelievers" (Kafirun)

does not refer to either Jews or Christians for both of those are respected as "People of Scripture."

The Koran prohibits the use of Jihad except for self-defense. It cannot be used for an attack in order to force conversion. In addition, Islam recognizes and values the life of each human being:

> *Let there be no compulsion*
> *In religion . . .*
>
> (Surah 2.256)

> *On that account, We ordained*
> *For the children of Israel*
> *That if any one slew*
> *A person, unless it be*
> *For murder or for spreading*
> *Mischief in the land*
> *It would be as if*
> *He slew the whole people . . .*
>
> (Surah 5.32)

These verses make it clear that assassinations are not compatible with Islam; in any armed combat, civilians are to be spared, and no thirst for revenge shall be permitted.

However, the lesser Jihad does include one Muslim country helping another Muslim country defend itself if it has been attacked. This type of military alliance is similar to that of NATO.

On the other hand, the great Jihad is the Jihad an-Nafs, the internal struggle of the individual with his own weaknesses, bad characteristics, bad habits, and his soul.

An engraving of a silver bowl from Persia (late fifteenth or early sixteenth century A.D.).

"...The best Jihad (for you) is (the performance of) Hajj."

(Hadith Number 128, Volume 4, Book 52)

Narrated by Abu Sa'id: I heard the Messenger of Allah say, "The best struggle is the true word in the presence of an unjust ruler."

(Hadith)

In the end, it is the basic religious duties such as praying, fasting, providing charity for the needy, and taking responsibility for the well-being of other human beings that show the Jihad an-Nafs, the daily struggle to become conscious of one's own responsibility.

One of the numerous octagonal motifs that can be found as decorations on bronze and silver jewelry boxes.

Festivals of Islam

Strictly speaking, Islam has only two festivals: the festival of the breaking of the fast ('Id al-Fitr), which lasts three days and takes place immediately after the fasting month of Ramadan, and the festival of sacrifice or pilgrimage ('Id al-Adha), which lasts four days and takes place on the tenth day of the Dhul-Hijrah, the twelfth month of the Islamic lunar calendar. The birthday of the Prophet usually falls on the seventy-first day after the beginning of the Hijrah, the twelveth day of the month Rabial-Awwal. This is not actually an Islamic festival, but it is celebrated in some countries.

The first day of 'Id al-Fitr and 'Id al-Adha are usually inaugurated with the 'Id prayer (Salatu-l-Id). It consists of two Rak'ahs and is recited between twenty minutes after sunrise and midday. According to the Sunnah, the two festivals should be celebrated within the community, and all Muslims should take part in them; thus, we are dealing with family festivities and with community actions as well.

'Id al-Adha remembers Abraham's test when God demanded that he sacrifice his son Ishmael. In the last moment, Abraham was prevented from killing Ishmael, and a lamb was sacrificed instead. This is the reason a lamb is slaughtered for the annual festival of sacrifice. The meat is distributed to the needy, to friends, and to relatives. According to the Sunnah, one should take a different route back when leaving the festival site:

Narrated by Jabir bin 'Abdullah: On the day of 'Id, the
Prophet used to return (after offering the 'Id prayer)
through a way different from that by which he went.

(Hadith Number 102, Volume 2, Book 15)

According to the interpretation of Imam an-Nawawis, using
different routes to and from festival sites increases the number of
sites for the devotion of God. On the Day of Judgment, these
routes will bear witness to the fact that the person covered the
distances in remembrance of God. In addition, one meets more
people on two different routes and, thus, has an opportunity to
speak with others. This is another indication that Islam views a
friendly word as charity.

Islamic Chronology

The Islamic calendar begins in the year of the Hijrah (622 A.D.) when Muhammad emigrated from Mecca to Medina. Unlike Western countries, Islamic countries do not use the solar year with 365 years and one day to even out discrepencies every four years. Instead, they use the lunar year. This consists of 354 days and has eleven days less than the solar year. There is no leap year, so the beginning of the new year gradually passes through all the seasons.

The names of the twelve Islamic months are as follows:

1. Muharram
2. Safar
3. Raby` al-awal
4. Raby` al-Thaany
5. Jumaada al-awal
6. Jumaada al-Thaany
7. Rajab
8. Sha`baan
9. Ramadhaan
10. Shawwal
11. Thw al-Qi`dah
12. Thw al-Hijjah

Personal Occasions — Stages in the Lives of Muslims

Birth

Immediately after the umbilical cord is cut, the Adhan (the call to prayer) is spoken into the right ear of a newborn. This symbolic act is supposed to remind one of the Covenant between the individual and the Creator. Thus, the first words that are spoken to the child result from the creed and the call to prayer.

When thy Lord drew forth
From the Children of Adam
From their loins
Their descendants, and made them
Testify concerning themselves (saying),
"Am I not your Lord
(Who cherishes and sustains you)?"
They said, "Yea!
We do testify!" (This), lest
Ye should say on the Day
Of Judgment, "Of this we
Were never mindful."

(Surah 7.172)

Baptism is not part of Islam; all living beings exist because of God's will and "in the Name of God." In addition, baptism does not make a person a believer; rather, it is his way of thinking and his daily behavior that make him a believer.

The Aqiqah is a sacrifice of thanksgiving offered out of joy for

the newly born. When a child is born, a lamb is slaughtered according to the Sunnah; the meat from the sacrifice is distributed to the needy as Sadaqah. Furthermore, the Sunnah commands that the hair of the child be shaved off. The weight of the shaved hair is matched in gold. A monetary value equal to this weight is distributed to the needy, assuming the family can afford it.

Islam very clearly condemns the interpretation that the birth of a boy is better than the birth of a girl; men and women are considered absolutely equal in Islam.

When news is brought
To one of them, of (the birth
Of) a female (child), his face
Darkens, and he is filled
With inward grief!
With shame does he hide
Himself from his people,
Because of the bad news
He has had!
Shall he retain it
On (sufferance and) contempt,
Or bury it in the dust?
Ah! what an evil (choice)
They decide on?
To those who believe not
In the Hereafter, applies
The similitude of evil.
To God applies the highest

Golden jewelry is a popular bridal gift. This is a Moroccan pendant (nineteenth century A.D.).

Similitude, for He is
The Exalted in Power,
Full of Wisdom.

(Surah 16.58-60; see also 87.8-9)

This verse of the Koran refers to the barbarous customs of pagan Arabs. These people considered the birth of a daughter as a misfortune or a shame. Sometimes, they even buried a newborn girl alive. Unfortunately, this cruel crime is still a terrible reality. Once in a while, newborn females in India are killed because the parents fear the shame and responsibility of paying a bridal dowry they cannot afford. In China, the government has decreed that a family may only have one child. Some parents kill newborn females because they fear that no one will provide for them in their old age. After determining the sex of the child in utero, the Chinese use abortion instead of killing a child after its birth.

Kill not your children
For fear of want: We shall
Provide sustenance for them
As well as for you.
Verily the killing of them
Is a great sin.

(Surah 17.31)

Male children are circumcised. Whereas circumcision at the time of Abraham was understood as a symbol of the Covenant with God according to the Old Testament, the circumcision of male descendants is not explicitly mentioned in the Koran.

255

Nevertheless, Islam views circumcision as a symbol of affiliation with the religious community. However, the practice of some Bedouin tribes of southwest Arabia, which consider the circumcision of male descendants as a test of courage within the scope of an initiation rite, cannot be traced back to Islam. The circumcision of male descendants is a part of the Fitrah (natural inclination), which emphasizes hygiene.

The circumcision of girls, the removal of all or part of the clitoris, is considered a mutilation of the genital. It is not compatible with Islam, which has a positive attitude towards the sexuality of both genders. The sheikhs of Egyptian or Sudanese origin represent a minority in regard to circumcising girls. They should refrain from spreading their personal and traditional interpretations under a false sense of etiquette and from misrepresenting their social position as "religious scholars." They often make use of dreadful justifications that could compete quite favorably with those of the trials of the Spanish Inquisition. The circumcision of girls is not demanded, recommended, or approved by the Koran or the Sunnah. In fact, the only mention of circumcision in the Sunnah involves boys.

The truth is that female circumcision could even be considered a prohibited procedure. The Sunnah does not allow the comparatively harmless procedures of tattooing, plucking the eyebrows for cosmetic purposes, or plastic surgery for purely aesthetic reasons because they are seen as changing the creation of God. Therefore, one must regard female circumcision, which is a much more serious change, as forbidden. Based on the Koran, female circumcision is a manipulation of God's creation. Unlike the circumcision of men, who do not suffer any loss on either a

physical or psychological level, the circumcision of women represents a grave intervention of the bodily functions and the psyche of women.

> . . .But he [Satan] said, "I will take
> Of Thy servants a portion
> Marked off;
> I will mislead them,
> And I will create
> In them false desires . . .
> The (fair) nature created
> By God . . ."

(Surah 4.118–119)

In Yusuf 'Ali's commentary on this Koran verse, he said that disfiguring Allah's creation has a physical and a spiritual significance. Disfiguring people and animals is contrary to their true nature. God created humans in purity; evil disfigures them.

In addition to finding the custom of female circumcision on the Arabian penisula, one also finds it on the African continent. The baseless media claim that this is intrinsically an Islamic custom is incorrect because Coptic Christians also carry out female circumcision. Female circumcision existed in the pre-Islamic period. Therefore, those who hold onto this custom are denoted by Muslims themselves as Jahel, people who still indulge in non-Islamic customs stemming from the time of ignorance (Jahiliyyah).

Typically, those women who insist on circumcision for girls were circumcised as girls themselves. Psychologically, these women seem to have swapped the role of traumatized victim for that of culprit.

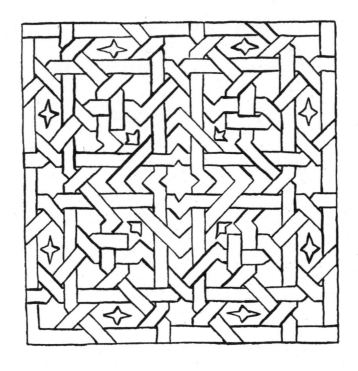

258

Many Islamic countries have joined the people of Europe and North America in attempting to end this barbaric custom. In Yemen, for example, the circumcision of girls and women has been legally prohibited, and the number of groups supporting this ban is increasing.

Marriage

> *And among His Signs*
> *Is this, that He created*
> *For you mates from among*
> *Yourselves, that ye may*
> *Dwell in tranquility with them,*
> *And He has put love*
> *And mercy between your (hearts),*
> *Verily in that are Signs*
> *For those who reflect.*

(Surah 30.21)

> *Permitted to you,*
> *On the night of the fasts,*
> *Is the approach to your wives.*
> *They are your garments*
> *And ye are their garments. . .*

(Surah 2.187)

The Islamic wedding (Katb kitab, the registration of marriage) requires two Muslim witnesses. The two verses cited above are recited because they include everything that forms the basis of marriage: a union founded on affection, respect, goodness, and understanding for one another and which conveys an atmos-

phere of security and protection, symbolized by the vivid image of the rope. This clearly demonstrates how absurd it is for parents to make engagements or wedding arrangements for children who have not even reached the age of puberty. Weddings in which girls and even women are forced by their relatives to marry are inadmissible in Islam and can be declared invalid and annulled. Several Hadiths speak of this:

> Narrated by Abu Huraira: The Prophet said, "A matron should not be given in marriage except after consulting her; and a virgin should not be given in marriage except after her permission." The people asked, "O Allah's Apostle! How can we know her permission?" He said, "Her silence (indicates her permission)."
>
> (Hadith Number 67, Volume 7, Book 62)

> Narrated by Khansa bint Khidam Al-Ansariya: That her father gave her in marriage when she was a tayyiba, [a divorced or widowed woman] and she disliked that marriage. So she went to Allah's Apostle and he declared that marriage invalid.
>
> (Hadith Number 69, Volume 7, Book 62)

At the time of the marriage, the Mahr (the dowry) is due:

> *And give the women*
> *(On marriage) their dower*
> *As a free gift . . .*

> (Surah 4.4)

The dowry belongs to the woman and not to her parents nor

to anyone else. Therefore, it is unjust to talk of purchasing and selling a woman and comparing the position of woman with that of a slave. Women and men are regarded as absolutely equal in Islam. The Mahr is a woman's financial security in times of crisis and can be compared with life insurance. The morning gift with which the Mahr is often confused was, in earlier times, a gift of the husband to his wife on the morning after their wedding night.

Another popular misconception is the interpretation that the man has the right to punish his wife. Unfortunately, it must be admitted that the behavior of some men towards their wives and towards other female relatives is open to criticism. However, this has nothing to do with Islamic belief. Rather, it represents the result of a traditional education:

> . . . *As to those women*
> *On whose part ye fear*
> *Disloyalty and ill-conduct,*
> *Admonish them (first),*
> *(Next), refuse to share their beds,*
> *(And last) beat them (lightly)* . . .

(Surah 4.34)

Because it uses the term "disloyalty" or even "rebelliousness" (nushuz, literally "revolt"), the passage seems to describe the intentional evil behavior of a woman towards her husband as well as that of a husband towards a woman. This includes behaviors that can be considered as mental cruelty or abusing a woman physically. We are not speaking of the small disputes of everyday life but of a grave and socially harmful behavior. Such behavior

A tile ornament from the Alhambra in Granada, Spain.

might be a crime or a betrayal of trust; different legal scholars define the behavior differently.

Unfortunately, the word "punish" is often translated as "hit." Yet all legal scholars categorically reject brutality and physical injury. The Prophet himself, a role model for Muslims and a foundation of Islamic legislation, has rejected violent clashes and physical violence, particularly violence against women:

> Narrated by Abdullah bin Zam'a: The Prophet said, "None of you should flog his wife as he flogs a slave and then have sexual intercourse with her in the last part of the day."
>
> (Hadith Number 132, Volume 6, Book 62)

> Narrated by Abdullah bin Zam'a: The Prophet then mentioned about the women (in his sermon). "It is not wise for anyone of you to lash his wife like a slave, for he might sleep with her the same evening."
>
> (Hadith Number 466, Volume 6, Book 60)

The punishment discussed in the Koran verse is regarded as the last resort after all attempts at mediation have failed. It is only symbolic and is not intended to hurt or torment someone. This is explained in the Hadith. It is included in the principle of retribution:

> *We ordained therein for them:*
> *"Life for life, eye for eye,*
> *Nose for nose, ear for ear,*
> *Tooth for tooth, and wounds*
> *Equal for equal." But if*
> *Any one remits the retaliation*

By way of charity, it is
An act for atonement for himself. . . .

(Surah 5.45; *see also* 4.178–179)

In another Hadith, a maid intentionally committed an evil deed. The Prophet was so enraged that he said, "If there were not anyone called to account in the world beyond, I would have caused you pain with this siwak [a twig the size of a tooth-brush]." This is a clear indication of the kind of measure the Prophet imagined as punishment for an evil deed if there were not any retribution on the Day of Judgment.

In cases involving nu<u>sh</u>uz, the woman has the right to go to the court as the last resort. If the husband won't heed the judge's warning, the judge imposes a penalty on the husband. This may be a fine paid to the wife, but can also be physical punishment and arrest. The punishment depends on the gravity of the offense. Usually, the offense is neglecting the obligation to pay alimony or other forms of support.

All Islamic law schools agree that a woman has the right to a divorce and to compensation for physical abuse, brutality, mental cruelty, or oppression.

In principle, however, the parties should make an attempt to reconcile before applying for divorce because, according to a Hadith, God hates divorce more than any other permitted act. However, divorce is legitimate when mutual hatred runs deep, living together becomes torment, and affection, tolerance, and respect are impossible.

. . . If ye come to a friendly
Understanding, and practice

Self-restraint, God is
Oft-forgiving, Most Merciful.

(Surah 4.129)

But if they disagree
(And must part), God
Will provide abundance
For all from His
All-reaching bounty,
For God is He
That careth for all
And is wise.

(Surah 4.130)

Divorces are also mentioned in the Sunnah when the wife feels aversion even though the husband has not given her any reason for feeling that way:

> The wife of Thabit bin Qais came to the Prophet and said, "O Allah's Apostle! I do not blame Thabit for defects in his character or his religion, but I, being a Muslim, dislike to behave in un-Islamic manner (if I remain with him)." On that, Allah's Apostle said (to her), "Will you give back the garden which your husband has given you (as Mahr)?" She said, "Yes." Then the Prophet said to Thabit, "O Thabit! Accept your garden and divorce her at once."

(Hadith Number 197 and 199, Volume 7, Book 63)

Narrated by Ibn 'Abbas: Barira's husband was a slave called Mughith, as if I am seeing him now, going behind Barira and weeping with his tears flowing

A tile ornament from the Alhambra in Granada, Spain.

down his beard. The Prophet said to 'Abbas, "O 'Abbas! Are you not astonished at the love of Mughith for Barira and the hatred of Barira for Mughith?" The Prophet then said to Barira, "Why don't you return to him?" She said, "O Allah's Apostle! Do you order me to do so?" He said, "No, I only intercede for him." She said, "I am not in need of him."

(Hadith Number 206, Volume 7, Book 3)

This second Hadith includes a clear rejection of the practice of returning a woman to her husband against her will. This practice is not Islamic, but it is often followed in some Islamic countries.

The divorce declaration of a simple announcement made three times is also prohibited. The end of marital relations by the man (Talaq raj'i) must include a four-month waiting period ('Iddah). The divorce must be declared on three different occasions, and unsuccessful attempts for reconciliation must have taken place after the first and second declaration of divorce. Furthermore, the husband is not allowed to expel the wife from the house during the period of revocation. If the wife is expecting a child by her husband, a divorce is generally inadmissible so as not to expose her to any social insecurity.

The Prophet once learned that someone had spoken three divorces on the same occasion. He stood up enraged and said: "Are you playing with Allah's scripture while I am still among you?" If a married couple has intimate relations during the 'Iddah, or if the filing for divorce is revoked, the move for divorce is cancelled. However, if the 'Iddah passes without the partners reconciling, they are divorced. When a divorce has been declared

valid three times, it becomes a final divorce (Talaq ba'in). According to Surah 2.230, the divorced couple are not allowed to marry again until the woman has married another man, has had marital relations with her new husband, and has been legally divorced from the second spouse. However, the other man is not permitted to marry her and divorce her just to make her halal (lawful or permitted) for her first husband. This regulation controls male capriciousess and establishes sanctions.

When the 'Iddah is over and the couple are divorced, the payment of the morning gift for the woman is due. Furthermore, the woman receives the compensation mentioned in Surah 2.236 as Nafaqa (alimony or compensation). In Surah 2.241, the Koran also contains a claim of alimony for the woman. This is independent of the above mentioned claims and is based on the financial situation of the man.

The question of custody of children has been included in books and in movies such as *Not Without My Daughter*. These works are very popular, and they have contributed to heightened prejudice against Islam. Unfortunately, children are kidnapped as described in this film, but these crimes are certainly not typical of the behavior of Muslim men. The behavior of these men must be classified as completely non-Islamic as confirmed by the following Hadiths:

> A woman came to Allah's Messenger and spoke: "My (divorced) husband wants to take away my son and he has helped me with fetching the water and in many other ways." There the Prophet said: "This is your father and this is your mother. Take, therefore, the one you desire by the hand." There the son took the

mother by the hand and she went with him.

<div align="right">(Hadith)</div>

A woman came once to the Prophet and spoke: "Allah's Messenger, my body was a receptacle for him my son, my breasts were a spring for him, and my lap offered protection for him. Now, however, his father has separated himself from me and wants to take him away from me." Allah's Messenger said: "You have the greater right over him as long as you do not marry anew."

<div align="right">(Hadith)</div>

These Hadiths make it clear that the rigid custody regulation in favor of the divorced husband in many Islamic countries is a tradition not based on Islam. These regulations can be often be traced back to the Middle Ages when children, and especially sons, still received their education and their apprenticeship from their father.

An infant usually remains with the mother. When the child is older and mature enough to make his own decision, he can be asked with which parent he would like to live. This is accepted Islamic doctrine. Each partner remains sole proprietor of the assests he or she had at the time of the marriage and of any assets received during the marriage.

Islamic law does not prohibit a wife from working. However, the man is expected to provide for his wife and family:

Men are the protectors
And maintainers of women . . .

(Surah 4.34)

Unfortunately, some translations of this verse are incorrect. In one version the verse becomes, "Men are superior to women ..." In addition, sometimes the header of the fourth Surah was translated with a derogatory word instead of the correct word, "women," and the word "hit" was used at the end of Surah 4.34. Later translations by non–Muslims used the word "priority" rather than "superiority." Of course, the effect was just as devastating.

The translations have led some people to believe that Muslim women must walk three steps behind her husband. Actually, in Islam, the household chores are not considered the sole duty of the wife, even though some patriarchal traditionalists would like everyone to believe that housekeeping is a purely female matter. The Prophet offered the best argument:

> Narrated by Al-Aswad: That he asked 'Aisha, "What did the Prophet use to do in his house?" She replied, "He used to keep himself busy serving his family, and when it was the time for prayer he would go."
>
> (Hadith Number 644, Volume 1, Book 11)

The last subject we need to discuss within the context of marriage is polygamy. Males in Western countries seem to have extraordinary fantasies about this particular topic, based perhaps on *One Thousand and One Arabian Nights*. The "Harem ladies," who have nothing better to do than to wait all day long in silky lingerie for their "lord," seems to appeal to Western males. This

270

mental picture, however, is completely misguided. The first religiously significant case of polygamy involved Abraham. He married Hagar because Sarah was too old to bear him a child. (Sarah did give birth to Isaac after Ishmael was born.)

Polygamy was customary in pre-Islamic society. It was not introduced by the Koran or even by traditional Islam. In the beginning, Islam controlled the practice by limiting the number of partners and by defining the conditions for polygamy:

> *If ye fear that ye shall not*
> *Be able to deal justly*
> *With the orphans,*
> *Marry women of your choice*
> *Two, or three, or four;*
> *But if ye fear that ye shall not*
> *Be able to deal justly (with them),*
> *Then only one, or (a captive)*
> *That your right hands possess.*
> *That will be more suitable,*
> *To prevent you*
> *From doing injustice.*

(Surah 4.3)

In order to create complete equality, each woman must live in a different house or apartment maintained by the husband. At the same time, the Koran says of polygamy:

> *Ye are never able*
> *To be fair and just*

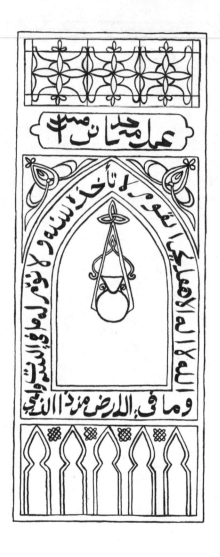

Muslim gravestone with excerpts from Surah 2.255, the Throne Verse.

As between women,
Even if it is
Your ardent desire . . .

(Surah 4.129)

The commentators all agree that polygamy is only allowed in order to prevent greater social injustices. Thus, the revelation of Surah 4.3 should be considered in its historical context. After the battle at Uhud, the Muslim community was faced with the problem of many widows and orphans. Their interests were preserved by marrying into the community, becoming equal and integrated family members. Thus, the wives of the Prophet were often older widows and divorced women.

Besides infertility and a surplus of women caused by war, another case where polygamy was important involved a woman who is chronically ill and confined to bed. Neither she nor her husband can lead a normal married life. The ideal in such a case is the self-sacrificing, sexless spouse. Unfortunately, the ideal seldom corresponds to reality. It is an open secret that some men take a concubine or satisfy their sexual needs with prostitutes.

Even non-Muslim societies recognize and condemn the double standard this situation represents. On the one hand, polygamy is condemned in principal as immoral. On the other hand, the "immoral" relations are silently accepted. An unspoken, universal agreement allows the sick woman to have support, comfort, and care from her husband and still allows the husband a normal family life. Marrying a second woman may provide psychological relief for all family members, including the children of the first wife.

The terms "first wife" and "second wife" are foreign to Islam

273

because they give the impression that there is a hierarchy. In fact, in polygamy, all women have the same rights. The equality of the women should not be overlooked in comparison to the girlfriend or concubine who adapts her entire lifestyle to the needs of the man but has no claim for payment and has no legal standing.

Despite all these considerations, one must remember that the idea of polygamy is not based on the sexual needs of the husband and that monogamy is to be preferred. The Prophet clearly prohibited his son-in-law from marrying another woman. According to a Hadith passed on by Tirmidi, the Prophet said: "When someone has two wives and dedicates himself to only one of them, then he will arise on the Day of Resurrection with one half of the body paralyzed."

> Narrated by Al-Miswar bin Makhrama: I heard Allah's Apostle who was on the pulpit saying, "Banu Hisham bin Al-Mughira has requested me to allow him to marry his daughter to Ali bin Abu Talib, but I don't give permission, and will not give permission unless Ali bin Abu Talib divorces my daughter in order to marry his daughter, because Fatima is a part of my body, and I hate what she hates to see, and what hurts her, hurts me."

(Hadith Number 157, Volume 7, Book 62)

Finally, we are dealing with women who are not working, who are not in a position to support themselves, or for whom divorce would create material difficulties and personal hardships.

Death and Funeral

Who say, when afflicted
With calamity, "To God
We belong, and to Him
Is our return."

(Surah 2.156)

Every soul shall have
A taste of death:
In the end to Us
Shall ye be brought back.

(Surah 29.57)

(To the righteous soul
Will be said)
"O (thou) soul,
In (complete) rest
And satisfaction!
Come back thou
To thy Lord,
Well pleased (thyself),
And well-pleasing
Unto Him!
Enter thou, then,
Among my Devotees!
Yea, enter thou
My Heaven!"

(Surah 89.27–30)

Verses of the Koran are recited at an Islamic funeral. In addition to Surah 36, the verses of Surah 89 quoted above are recited after the Al-Fatihah and during the death prayer. The death prayer is performed while standing, which means that it includes neither bowing nor falling to one's knees.

A Muslim on his deathbed still tries to recite the words of the creed. The Muslims surrounding him try to help by performing the Shahadah in loud voices. After death, the attendants pour water on the corpse. According to the Sunnah, they begin pouring on the right side of the body, just as one would for the ritual cleansing for prayer, though camphor is mixed with the water for this final purification. Then, the attendants wrap the corpse in three white cotton sheets. These are the only coverings for the body during the funeral.

The service for the dead occurs as soon as the dead is covered in the burial shrouds. According to Islamic understanding, burying a person as quickly as possible after death is a sign of great respect towards the dead person. This is why most Muslims who die of natural causes are buried within twenty-four hours. The assumption that Muslims find corpses or, more specifically, the decaying process disgusting is ridiculous. If it were truth, Muslims would not use their bare hands to put a body wrapped only in cotton sheets into the ground.

> Narrated by Abu Huraira: The Prophet said, "Hurry up with the dead body for if it was righteous, you are forwarding it to welfare; and if it was otherwise, then you are putting off an evil thing."

> (Hadith Number 401, Volume 2, Book 23)

If possible, the grave is dug parallel to Mecca so that the deceased can be laid on the right side of his body with his face turned towards the Ka'bah. This reflects the hope to belong among the believers and the righteous on Judgment Day. As the dead body is lowered into the grave, the mourning community tries to prepare him for the questioning in the grave that is carried out by two angels. They call to him with the creed and other statements of belief (Day of Judgment, Resurrection, Paradise, and Hell).

Islam does not have any particular death or funeral cult because death represents only an intermediate stage in regard to Resurrection. For this reason, excessive expenses for the grave are prohibited. Loud lamenting and wailing are also seen as expressions of excessive pain for the dead. Instead, the mourners donate a small portion of the dead person's estate to the needy. They ask God to count this donation as Sadaqah and to reward the dead person for it in the world beyond. The gravestone is inscribed with excerpts from the Koran. Typically, the formula is, "Here lies the servant of God . . ."

Islam prohibits (haram) turning burial places into pilgrim sites or prayer places because of the danger of <u>Shirk</u> (polytheism) through excessive personality cult. The Prophet Muhammad himself warned of the danger even while he was dying, and several Hadiths warned of such customs. When Muhammad passed away, some people started to gather around his corpse despite his warning. They began to lament and kiss him. Abu Bakr, one of the closest friends of the Prophet, spoke to remind the people once more of the Shahadah. He said:

"O oath-taker! Don't be hasty." When Abu Bakr spoke, 'Umar sat down. Abu Bakr praised and glorified Allah and said, "No doubt! Whoever worshipped Muhammad, then Muhammad is dead, but whoever worshipped Allah, then Allah is alive and shall never die."

(Hadith Number 19, Volume 5, Book 57)

Afterwards, Abu Bakr also recited the following words from the Koran:

> *Muhammad is no more*
> *Than an Apostle: many*
> *Were the Apostles that passed away*
> *Before him. If he died*
> *Or were slain, will ye then*
> *Turn back on your heels?*
> *If any did turn back*
> *On his heels, not the least*
> *Harm will he do to God;*
> *But God (on the other hand)*
> *Will swiftly reward those*
> *Who (serve him) with gratitude.*

(Surah 3.144)

Considering the Hadith and the Koran verse, it is all the more incomprehensible that the graves of religious guides or saints, (including the Sufi saints) become places of worship. Muslims are also prohibited from lamenting loudly, ripping their clothes off, or chastising themselves at the funeral of religious guides or other people.

Narrated by 'Abdullah: the Prophet said, "He who slaps his cheeks, tears his clothes and follows the ways and traditions of the Days of Ignorance is not one of us."

(Hadith Number 382, Volume 2, Book 23)

PART THREE

Oriental
Superstition

Apocryphal or Unauthorized Additions

Any addition to a permitted procedure is considered apocryphal when it is improper according to the Koran or Sunnah, regardless of whether it involves words or actions. One of the best examples of these apocrypha is the prohibited form of Ruqya. A healthy person recites the Ruqya al-Taweez (refuge in God from an evil) from the Koran for the benefit of someone who is ill. Because it is based on a Surah, the Ruqya is permitted:

> *We send down (stage by stage)*
> *In the Qur-an that which*
> *Is a healing and a mercy*
> *To those who believe.*
> *To the unjust it causes*
> *Nothing but loss after loss.*

(Surah 17.82, *see also* 10.57)

According to Hadiths, stroking across the body of a sick person is not prohibited:

> Narrated by 'Aisha: The Prophet used to treat some of his wives by passing his right hand over the place of ailment and used to say, "O Lord of the people! Remove the difficulty and bring about healing as You are the Healer. There is no healing but Your Healing, a healing that will leave no ailment."

(Hadith Number 646, Volume 7, Book 71)

However, only quotations from the Koran or from the Hadiths may be spoken. In addition, the reader must be aware of the fact that he himself has no influence on the course of the disease and

A Sufi cross of light.

282

or the sick person; this lies solely in God's hands. As soon as one of these criteria is not fulfilled, we are dealing with an apocryphal, a prohibited form of the Ruqya because it is connected with <u>Sh</u>irk (polytheism). The Ruqya is particularly prohibited when it is mingled with magic, strange sayings, formulas, or even with calling on Satan, the demons, or the jinn.

Other apocryphal additions occur with the supplication for inspiration, the Salat al Istikhara. This is the case when asking for help in making the right decision. In this case, the person opens the Koran and considers the first verse that greets his eye an inspiration from God. Some superstitious Christians use the Bible for the same purpose.

Another variety of this apocryphal form of supplication involves opening the Koran and then flipping back seven pages (due to the seven heavens spoken of in the Koran). The reading begins with the eighth word on the eighth line of the eighth page. Again, this is supposed to represent an answer for the questioner.

Another form of the forbidden Istikhara prayer is Tasbih, which uses the Misbaha. Using the pearls, one counts the names Allah, Muhammad, and Abu Jahel (an unbeliever.) If the last pearl of the chain ends with the name of Allah, then the planned project is considered to be very good. If it ends with the name Muhammad, the project is not as good, but still acceptable. However, if the chain ends with the name Abu Jahel, the planned project has something bad or wrong associated with it. This is a rather primitive form of superstition because one can simply divide the thirty-three or ninety-nine pearls of the chain by the number of names and then one knows what the result will be. In other cultures, children or young lovers use a similar form of

superstition when they count the petals on daisies.

Finally, the cross of light that some Sufis use following the actual Istikhara prayer is also considered improper. In this case, the person uses the middle finger of the left hand to draw seven times on the palm of his right hand while speaking the Arabic letters "ha," "mim," "ha," "lam," and "ya."

Whether or not someone may ask another person to pray for him for the inspiration is unclear. Neither the Koran nor the Sunnah mentions the practice. Therefore, we do not know if we are dealing with something that is prohibited or permitted. However, each Muslim must question all of his own actions:

> From Al-Hassan Ibn'Ali: I treasured the following words of Allah's Prophet: "Leave this which awakens doubt in you for that which does not awake doubt in you; for truth causes peace and falseness doubt."

> (Hadith Number 117)

The character of the Istikhara prayer doesn't seem to permit this plea for another person because inspiration is an entirely personal matter. However, nothing negative can be said about the practice when supplications and the Istikhara express solidarity and show a social and amicable aspect.

On the other hand, the practice becomes suspect when the questioner or supplicant assumes that the other person has a particularly good influence on the final result of the Istikhara prayer, or the supplicant assumes that God hears the prayer of the other person but not his own. This case mingles aspects of poly-theism with the request. In fact, through prayer, an individual's contact with God is direct. A mediator is not necessary, so the

practice is prohibited. Generally, anyone who prays to God for the inspiration should not give up his supplication until his supplication is heard or until he is no longer interested in receiving an answer to his prayers.

All forms of apocryphal additions indicate a lack of confidence in God and a lack of confidence in a merciful destiny. These additions are based on the erroneous assumption that these superstitions can somehow have a positive effect.

The Vow — Al-Na∂hr

One must differentiate between the permitted and the prohibited vow. What is decisive is what the promise is and what the content of the oath is:

> Narrated by Abdullah: The Prophet said, "Whoever has to take an oath should swear by Allah or remain silent."
>
> (Hadith Number 844, Volume 3, Book 48)

If the oath is taken on something other than God, the oath is prohibited because it is mingled with Shirk (polytheism). Furthermore, the vow must not have any kind of content, purpose, or intention that goes against the commandments of the Koran. In addition, the procedure for the fulfillment of the vow must be compatible with Islam:

> Narrated by 'Aisha: The Prophet said, "Whoever vows that he will be obedient to Allah, should remain obedient to Him; and whoever made a vow that he will disobey Allah, should not disobey Him."
>
> (Hadith Number 687, Volume 8, Book 78)

> Narrated by 'Abdur-Rahman bin Samura: The Prophet said, "O 'Abdur-Rahman bin Samura! . . . whenever you take an oath to do something and later you find that something else is better than the first, then do the better one and make expiation for your oath."
>
> (Hadith Number 619, Volume 8, Book 78)

Thus, vows that would cause harm to oneself or to someone else, especially those whose intent is to kill, are prohibited. Vows whose aim is something prohibited or whose purpose is permitted but which can only be achieved through prohibited actions are called vows of sin (Nadhr al-Ma'asir).

The Prophet scolded those who frequently took oaths in connection with business and trade affairs because the vows were often made with deceitful intentions. In addition, the respect for God's Name is diminished with frequent swearing. Nevertheless, frequent intentional swearing is normal in connection with goods in the souks (markets, bazaars).

Another superstitious action concerns vows at the graves of prophets, so-called saints, martyrs, and religious guides. This kind of vow is denoted Nadhr Lilkubur and is considered haram (prohibited) because it shows devotion to a person who has passed away. Again, this is a form of polytheism. Such an oath might be sworn out of gratitude for a healing and might involve the sacrifice of a lamb in honor of a deceased sheik. Instead of sacrificing a lamb, one might donate money in honor of a particular prophet. In some cases, bills are thrown into the enclosure of the grave. Significantly, some enclosures even have slots intended for this purpose.

Other people take oaths to celebrate the birthday of the Prophet Muhammad (Maulid Nabi) in case they or someone they love is healed. This vow is also prohibited because neither the Koran nor the Sunnah discusses such behavior, and thus, no one knows if it is acceptable. However, the danger of the cult of personality is present, as is polytheism. The principle that things doubtful should be left alone applies here.

Based on the Hadiths, penance must be done for a prohibited

oath. The penance may consist of donating goods or money for the public welfare or of fasting days in addition to Ramadan, the month of fasting.

Amulets

Before discussing amulets (At-Tama'im) that ward off misfortune or harm, some explanations of the "evil eye" are necessary because the evil eye is considered a reality in Islam:

> Narrated by Abu Huraira: The Prophet said, "The effect of an evil eye is a fact . . ."
>
> (Hadith Number 636, Volume 7, Book 71)

The evil eye is particularly relevant in regard to jealousy or envy (Hasad). This can express itself in various forms. The purpose of this look is to try to influence a person's material or spiritual well-being or even to destroy it. Envy can express itself in tangible or obvious actions, or it can create negative effects in a much more ethereal way. The Koran mentions the negative influence of envy:

> *Say: I seek refuge*
> *With the Lord of the dawn,*
> *From the mischief*
> *Of created things;*
> *From the mischief*
> *Of darkness as it overspreads;*
> *From the mischief*
> *Of those who practise*
> *secret arts,*
> *And from the mischief*
> *Of the envious one*
> *As he practices envy.*
>
> (Surah 113)

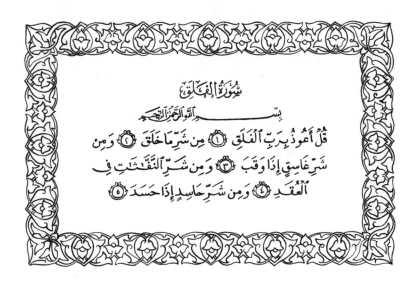

سُورَةُ الفَلَق

بِسْمِ اللهِ الرَّحْمَنِ الرَّحِيمِ

قُلْ أَعُوذُ بِرَبِّ الْفَلَقِ ۝ مِن شَرِّ مَا خَلَقَ ۝ وَمِن شَرِّ غَاسِقٍ إِذَا وَقَبَ ۝ وَمِن شَرِّ النَّفَّٰثَٰتِ فِي الْعُقَدِ ۝ وَمِن شَرِّ حَاسِدٍ إِذَا حَسَدَ ۝

A Surah of protection (Sura-t-al-Falaq).

290

This is one of the Surahs of protection which are often recited during prayer. This Surah is a clear statement that nothing exists or develops except with God's will. In the end, everything is subject to his power, the good as well as the evil, for God is the Creator of all things.

In addition to this prayer of protection, one is supposed to say a Ruqya if the evil eye has given someone a disease or other problem. Unfortunately, many people tend to attribute all negative events and illnesses to the evil eye, even if there is a logical explanation:

> Narrated 'Aisha: The Prophet ordered me or somebody else to do Ruqya (if there was danger) from an evil eye.

> (Hadith Number 634, Volume 7, Book 71)

The words "Masha Allah" (that which Allah wills) are spoken when one expresses admiration for or recognition of something. The admiration becomes envy when one expresses admiration several times without the words "Masha Allah." When one sees signs of envy, one replies "Allah-umma salli ala an-Nabi" (God's blessing and grace upon the Prophet).

Although both the Koran and the Sunnah have procedures for dealing with the consequences of the evil eye, one can find a variety of different amulets and pendants to defend against evil sold in souks.

Amulets in the form of an eye or in the form of a pointed slipper offer protection from the evil eye of the envious. The color of the eye in the amulet is always blue because blue is supposed to have a protective power. The eye in the amulet is

A pendant for storing verses of the Koran, for example, Surahs of protection. In the pre-Islamic period, rulers kept poison in pendants.

supposed to reflect the evil eye back onto the envier. The pointed slipper is often decorated with a blue stone; this is supposed to symbolize kicking the face of the envier. In many countries, one receives a blue stone as a little token with the purchase of a piece of jewelry. Often, a blue or turquoise stone is part of the clasp of protective necklaces.

The "hand of Fatimah" is also supposed to have a protective effect. The thumb of this hand stands for the Prophet Muhammad, the other four fingers for his daughter Fatimah, his wife Khadijah (Fatimah's mother), the Virgin Mary, and finally Asiya (Pharaoh's wife, who saved Moses from the Nile and took care of him). These women were considered the most perfect in the world. Later on, the positions of Asiya and Mary were taken by Hassan and Hussein, the children resulting from Fatimah's marriage with 'Ali.

Often, one can buy other mixed forms of amulets or pendants. The combination of the "hand of Fatimah" and the blue eye is particularly popular. Hand and eye amulets are combined with Koran verses, particularly with Surahs of protection.

The tradition of these amulets goes back to the time of the Jahiliyyah. The amulets combine ancient oriental practices, post-biblical Jewish traditions, and Islamic elements. As with incantations and magic sayings, we are dealing with Shirk (polytheism) because the person using such charms is not relying on God for protection.

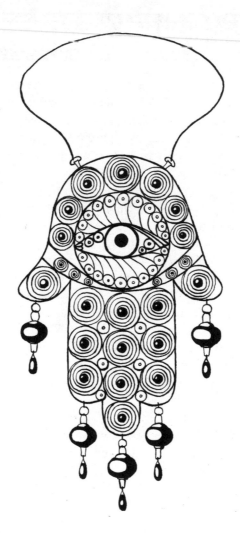

An amulet that combines an eye with the "hand of Fatimah."

294

Narrated by 'Uqba Ibn Amir that he came to the Prophet among a group of ten. The Prophet accepted from nine of them the proclamation of faith, however, He rejected the tenth. "What is wrong with him?" they wondered. "On his arm there is an amulet," the Prophet replied. Upon these words, the man ripped off the amulet and the Prophet accepted his proclamation of faith and spoke: "Whoever carries this has committed Shirk."

(Hadith)

Amulets that contain verses from the Koran or supplications are permitted. They must consist of scripture only; nothing else is permitted. One cannot take amulets decorated with verses of the Koran or anything else on which the name of God is inscribed into bathrooms because these are regarded as unclean.

Burning incense or other burnt offerings (Bakhur) is another way to protect oneself from misfortune. This superstition has been found in almost every culture for millennia. For example, according to the Old Testament, burning incense was a way to make God merciful; in Psalm 141.2, burning incense is equal to a prayer. The Catholic Church still uses incense as part of its liturgy. In other cultures, burning incense was used as a means to achieve a trance state.

The basic idea of all these applications lies in the belief that incense can affect something on a higher level of consciousness. This concept may have its origin in the use of cauterization to heal wounds and to keep them free of germs. This same concept required burning all the objects that came into contact with

people who suffered from highly contagious diseases, such as the Black Death. Obviously, people drew conclusions about the power of an extrasensory cleaning effect.

Some people also believe that a handprint on the walls of a house will prevent misfortune. The blood comes from a lamb, slaughtered when a child is born. This custom, which is seldom encountered today, was supposed to protect the newborn.

Talismans, or lucky charms, are also amulets. One can find a surprising number of talismans. For example, the horseshoe and the portrait of a horse's head are widely accepted in many parts of the world, including the Middle East. If one thinks of the sentimental value horses have in Arabic countries, this custom appears less peculiar. People usually attach these talismans over the front door, hoping that only good things will happen in the home.

Another typical superstition is the custom of attaching little ribbons to the fenced enclosures of the graves of prophets, sheiks, and Sufi saints and martyrs. These ribbons are considered lucky charms. People tie them on the fence hoping, or rather praying, that a particular wish will be fulfilled. A variation involves attaching padlocks to fenced enclosures. Sometimes "wish lists" are thrown into the enclosed graves. With all of these variations, the person buried in the enclosure is supposed to intercede with God on the supplicants' behalf.

As is true with amulets, confidence in talismans means a denial of Tauhid (belief in the oneness of Allah; the monotheistic creed) and, thus, is Shirk (polytheism).

Narrated by Abu Huraira: The Prophet said, "Avoid the seven great destructive sins." The people enquire, "O Allah's Apostle! What are they?" "He said, "To join others in worship along with Allah, to practice sorcery"

(Hadith Number 28, Volume 4, Book 51)

Belief in Spirits

Even today, superstitions about the jinn are almost identical with those from the time of the Jahiliyyah. In some respects, superstitions are even more developed and more imaginative.

What has remained the same is the concept that although the jinn are usually not visible, they have a definite physical appearance. A distinction is still made between male demons (ifrite) and female demons (succubi). However, such details cannot be found in the Koran.

According to tradition, female spirits appear as beautiful young women; male ones, on the other hand, often appear as terrifying figures such as giants, or as usual human beings. When they appear as humans, they are recognizable by the shape of their eyes. This involves an unusually distinctive sideward swing of the eyebrows as well as a shifty look. In addition, the jinn have descendants among themselves and with human partners.

As was mentioned in the discussion of the pre-Islamic period, spirits frequently take the shape of particular animals. The list includes donkeys, dogs, cats, ravens, owls, snakes, scorpions, camels, goats, apes, roosters, and chickens with their chicks.

Now and then, spirits of the underworld and of the earth are encountered at places where the earth and the underworld connect: in caves, mountain gaps, dark valleys, ravines, graves, hot springs, and wells. They are also found close to or in trees and bushes, the roots of which reach down into the earth. The ghoul, a particularly evil spirit, is still believed to be up to no good in the desert.

Household spirits are considered good-natured and benevolent because they want to be particularly close to humans. The

A grave enclosure decorated with little ribbons and padlocks.

evil spirits lie in wait on the threshold. Ever since people began to settle down, the world outside one's own walls has been perceived as threatening.

In order to calm the spirits when building a house, a tent, or any dwelling that is to be used for a long period of time, one uses the formula "Dastur ya sahib al-mahall" (with your permission, O owner of this place). Such sayings were known in the pre-Islamic period. Animal sacrifices are as important today as they were in earlier times. The bloody sacrifice placates the spirits.

The custom of applying a bloody handprint on the wall of the house to prevent misfortune is also counted as one of these sacrifices. The fear is that a spirit (perhaps in the form of an illness) might take possession of the newborn baby (Aqiqah).

In earlier times, playing a flute or whistling was supposed to attract the spirits. One Hadith is particularly worth mentioning to refute this idea:

> Narrated by 'Aisha: Allah's Apostle came to my house while two girls were singing beside me the songs of Buath [a story about the war between two tribes before Islam]. The Prophet lay down and turned his face to the other side. Then Abu Bakr came and spoke to me harshly saying, "Musical instruments of Satan near the Prophet?" Allah's Apostle turned his face towards him and said, "Leave them." When Abu Bakr became inattentive, I signaled to those girls to go out and they left. It was the day of 'Id, and the Black people were playing with shields and spears; so either I requested the Prophet or he asked me whether I would like to see the display. I replied in the affirma-

tive. Then the Prophet made me stand behind him and my cheek was touching his cheek and he was saying, "Carry on! O Bani Arfida, till I got tired." The Prophet asked me, "Are you satisfied? Is that sufficient for you?" I replied in the affirmative, and he told me to leave.

<div align="center">(Hadith Number 70, Volume 2, Book 15)</div>

Another way to refute this old concept is to look at the attitude towards blowing. Blowing is important in both playing the flute and in whistling. In addition, according to the Sunnah, one should blow over the left shoulder after one has a nightmare. Still today, people disapprove of blowing. For example, people are told not to blow on dishes or beverages that are too hot to cool them. This disapproval is probably closely related to the superstition that blowing will attract spirits.

The jinn are held responsible for most physical illnesses, and they are also seen as the cause of most nervous disorders, from those of no real consequence up to those that cause paralysis and madness. However, if we think of the term "jinn" as meaning thoughts, the jinn cannot be entirely rejected as the cause of nervous diseases, especially with illnesses such as schizophrenia in which we are dealing with a mental condition that dominates the psyche and seems to have the patient under a spell. Thus, even today, a madman is regarded as majnun, someone obsessed by a demon.

Soothsaying

Soothsaying is still practiced in Islamic countries. A number of methods are used to predict the future. The most common is reading the palm. Having confidence in soothsaying is regarded as Kufr (disbelief) because only God has knowledge about what will happen. For humans, these things are hidden:

> *Say, None in the heavens*
> *Or on earth, except God,*
> *Knows what is hidden . . .*

> (Surah 27.65)

According to one of the Hadiths:

> "The one does not belong to us who seeks for an omen or for whom an omen is sought, who foretells and who is foretold, who performs magic or asks someone to perform magic for him."

A detail from the front cover of a Koran (1313 A.D.).

Glossary

Term	Explanation
Ad-Dawar	Circumambulation
Adhan	Call to prayer
Ahl al-Kitab	People of the Book
Al-Azlam	Oracle Arrows, though some times stones (see Sahib al-Azlam)
Al-Shari'ah	Islamic law; the sacred law of Islam
Ayyub	Job
Aqiqah	Sacrifice offered out of gratitude for the birth of a child
'Asr	Afternoon prayer
as-Salah	Prayer; any one of the five daily or obligatory prayers
ash-Shi'r al-'abur	Sirius
Bakhur	Incense materials
Bismillah	"In the name of Allah"
Chador	Covering shawl for women
Dajjal	False Messiah
Da'ud	David
Dhikr	Remembrance, usually of Allah, individually or in a group
Dhimmi	Non-Muslim living under the protection of a Muslim state

Dhul-Hijrah	Pilgrimage month; the twelfth month of the Islamic lunar year
Diyah	Blood money
Du'a'	Supplication
Fajr	Dawn prayer (actually a bit before dawn); early morning prayer
Fardz	Duty
Fiqh	Islamic jurisprudence
Ghusl	Ritual cleansing of the entire body that occurs at least once a week
Hadith	Saying or tradition of Muhammad
Hafiz	People who know the entire Koran by heart
Hajj	Great pilgrimage to the Ka'ba in Mecca performed in Dhul-Hijrah
Halal	Lawful or permitted
Haram	Holy district of the Ka'bah
haram	Prohibited
Hasad	Envy, jealousy
Hawwa	Eve
al-Hijaz	Coastal strip of the Arabian Peninsula on the Red Sea that includes Mecca and Medina, the two holiest cities of Islam

Hijrah	Beginning of the Islamic calendar, 622 A.D.; year when Muhammad emigrated from Mecca to Medina
Ibrahim	Abraham
'Id al-Adzha	Festival at the end of the Hajj; begins the tenth day of Dhul-Hijrah
'Id al-Fitr	Festival at the end of the month of Ramadan marking the end of the month of fasting
Iddah	Fixed period of time between the three declarations of divorce
'Ifrit	Demon
Iftar	Meal eaten after sunset during Ramadan, the month of fasting
Ihram	State of sanctity during the pilgrimage
'Iyadh	Seeking refuge in Allah
Imam	Prayer leader; may be a religious teacher; person who delivers the sermon
Injil	Gospels
Isa	Jesus
Isha	Late evening prayer
Istikhara	Supplication for divine inspiration; the "seeking" prayer
Jibril	Gabriel
Jahannam	Fires of Hell; the abyss

Jahel	Idol worshipper; unknowing person
Jahiliyyah	Pre-Islamic period of idol worship; termed the Age of Ignorance (of Islam)
Jihad	Lesser jihad, an internal struggle against personal faults, sins, and evil; external jihad, a violent struggle against evil or injustice
Jinn	Spirit created by God from fire, may appear in different forms
Jumuah	Friday sermon
Kafirun	Unbelievers; those who repudiate the revelation (Jews and Christians do not belong to this category)
Kahin	Soothsayer; diviner
Katb kitab	Islamic wedding (registration of a marriage)
Khutba	Sermon
Kufr	Nonbelief
Laila	Night
Lut	Lot
Maghrib	Sunset prayer
Mahr	Bridal gift
Majnun	Mad; obsessed
Makruh	Disapproved
Malakut	Kingdom of Heaven
Masjid	Mosque

Mi'raj	Muhammad's ascension to heaven
Mihrab	Prayer niche
Minbar	Pulpit
Misbaha	Muslim rosary
Muezzin	Crier for prayer
Mufti	Legal scholar; highest legal official of a state
Muhammad	Mohammed
Mulsaq	To foist something on someone (child); something that is pasted on or joined to something else; not usually negative in meaning
Munkar	Reprehensible
Murad	Desired person, object, or thing
Murid	Someone who desires
Musa	Moses
al-Mushtari	Jupiter
Mut'ah	Temporary marriage stipulated (contractually) for a specific period of time, abhorred by Sunni Muslims
Nafaqa	Alimony; compensation
Nakir	Negation; rejection; denial; disavowal; repugnant; abominable; bad
Nuh	Noah
Qadar	Predestination
Qiblah	Muslim direction of prayer; the Ka'bah

Qiyam	Prayer in a standing position
Qur'an	Koran
Rajm	Stoning to death; casting stones symbolically at the devil during the Hajj
Rak'ah	Section of prayer
Ramadan	Month of fasting; nineth month of the Islamic lunar year
Ruku'	Ritual bowing of the upper body during prayer
Ruqya	Seeking refuge in God from evil
Sadaqah	Charity
Sahib al-Azlam	"Keeper of the Arrows"
Sahih	Real, authentic
Shahadah	Islamic creed; the act of confessing faith in God alone ("There is no other besides God")
Sheikh	Islamic theologian
Shi'ah	Party of Ali, Muhammad's son-in-law; law school of the Shiites
Shi'ites	Muslims who live according to the Shi'ah in addition to the Sunnah
Shirk	Polytheism; adding anything to the belief in one single God; idol worship
Sujud	Ritual prostration during prayer

Suhail	Canopus, a star in the Carina constellation
Suhur	Meal eaten before sunset during Ramadan
Suleiman	Solomon
Sunnah	Collection of Hadiths that serve as the body of Islamic guidance
Sunnites	Muslims who live according to the Sunnah
Takbir	Speaking the formula "Allahu Akbar" during prayer
Talaq ba'in	Final divorce
Talaq raj'i	Declaration of a revocable divorce by the husband
Talbiyah	Statement of intent to perform the Hajj or 'Umrah in response to Allah's command to do so
Tarawih	Communal prayer consisting of recitation of the Koran after the sunset meal (which breaks the fast) and the sunset prayer during Ramadan
Tasbih	See Misbaha
Tashahhud	Section of prayer in which the Shahadah is spoken
Tauhid	Belief in the oneness of Allah; monotheism
Taurah	Torah
Tayyiba/Tayyibah	Divorced or widowed woman

'Umrah	Lesser pilgrimage
'Utarid	Mercury
Witr	Odd number of prayer rak'ahs (usually three, each consisting of reciting part of the Koran while standing, bowing, and prostrating)
Wudu'	Ritual partial washing before each prayer
Yahya	John
Ya'qub	Jacob
Yunus	Jonah
Yusuf	Joseph
Zakat	Giving alms; literally, purification
Zina	Fornication and adultery
Zuhara	Venus
Zuhr	Midday prayer

Index

Prayer (as-Salah), 77,
187–207, 209–215
attitude during, 190
clothing for, 201–207
Dhikr (remembrance), 87,
191, 214–215
Du'a' (supplication), 191,
213–214
Fardz (obligatory), 191,
209–213
kinds of, 191–195
language of, 193
99 names of God, 80,
81–87, 214
as pillar of Islam, 77,
189–190
purpose of, 189–190
rituals, 193–201, 207,
209–215
rugs, 207
sequence, 209–215
times of, 191
women and, 195, 201–205
Predestination (Qadar), 79,
97–110
belief and, 104–109
deeds and, 97–99
God's omnipotence and,
99–101
passivity and, 99
responsibility and, 109–110
suffering/punishment and,
100–104

Pre-Islamic Arabia. *See*
Arabia, pre-Islamic
Prophets, 14
Quraysh tribe, 43–46, 50, 52
Ramadan, 193
fasting (Siyam/Saum),
225–227, 230, 249
Koran reading during, 226
rituals, 225–230
timing of, 225, 226
Ravens, 62, 65
Resurrection, 79, 180
Roman Catholic Church, 14
Safa, 28, 237
Sa'iba, 40
Satan (Iblis or Shaytan), 79,
139 163
Adam/Eve and, 141,
144–145, 146–153
arrogance of, 143, 144,
153–154
death of, 143
defined, 139
evil and, 149
man's power vs., 143–145,
149–151
motivation of, 145–146
protection from, 159–161
stoning of, 28, 238
Shiites, 71
Solomon, 168
animals (Ad-Daabba) and,
168